P9-DTN-267

POLYMER CLAY
FOR BEGINNERS

Inspiration, techniques, and simple step-by-step
projects for making art with polymer clay

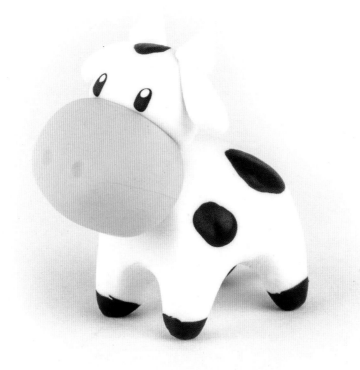

Emily Chen

DISCARD
CARLSBAD
CITY LIBRARY
Carlsbad, CA
92011

Brimming with creative inspiration, how-to projects, and useful information to enrich your everyday life, Quarto Knows is a favorite destination for those pursuing their interests and passions. Visit our site and dig deeper with our books into your area of interest: Quarto Creates, Quarto Cooks, Quarto Homes, Quarto Lives, Quarto Drives, Quarto Explores, Quarto Gifts, or Quarto Kids.

© 2019 Quarto Publishing Group USA Inc.

Artwork and text © 2019 Emily Chen, except select photographs on pages 8-11 and 17 © Shutterstock.

First published in 2019 by Walter Foster Publishing, an imprint of The Quarto Group.
26391 Crown Valley Parkway, Suite 220, Mission Viejo, CA 92691, USA.
T (949) 380-7510 **F** (949) 380-7575 **www.QuartoKnows.com**

All rights reserved. No part of this book may be reproduced in any form without written permission of the copyright owners. All images in this book have been reproduced with the knowledge and prior consent of the artists concerned, and no responsibility is accepted by producer, publisher, or printer for any infringement of copyright or otherwise, arising from the contents of this publication. Every effort has been made to ensure that credits accurately comply with information supplied. We apologize for any inaccuracies that may have occurred and will resolve inaccurate or missing information in a subsequent reprinting of the book.

Walter Foster Publishing titles are also available at discount for retail, wholesale, promotional, and bulk purchase. For details, contact the Special Sales Manager by email at specialsales@quarto.com or by mail at The Quarto Group, Attn: Special Sales Manager, 100 Cummings Center, Suite 265D, Beverly, MA 01915, USA.

ISBN: 978-1-63322-632-6

Digital edition published in 2019
eISBN: 978-1-63322-633-3

Page Layout: Krista Joy Johnson

Printed in China
10 9 8 7 6 5 4 3 2 1

APRIL 2019

POLYMER CLAY
FOR BEGINNERS

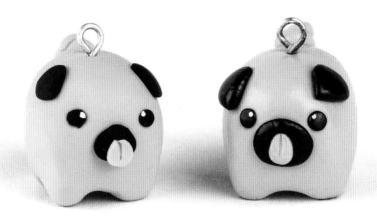

TABLE OF CONTENTS

Introduction . 6

Tools & Materials . 8

Techniques . 12

Baking Guidelines . 16

Troubleshooting Tips . 18

Finishes . 20

Projects 22

FOOD 24

Macaron . 25

Chocolate Chip Cookie . 28

Fruit Canes . 33

Fruit Tart . 42

Rainbow Cake . 46

Swiss Cheese Charm . 56

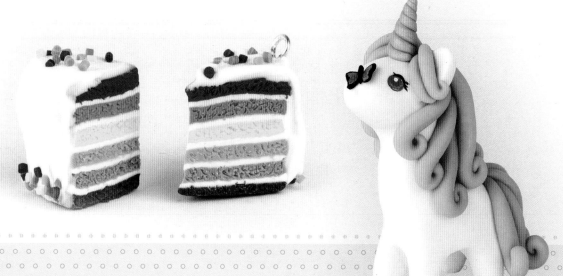

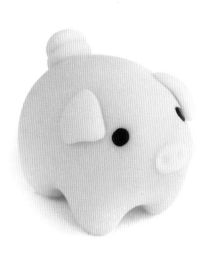
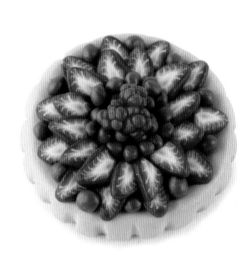
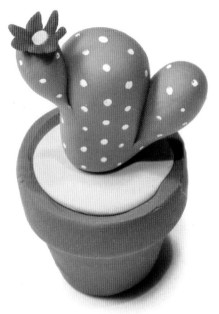

ANIMALS 60

Pug Charm .61

Cat. .68

Pig .76

Cow .84

Unicorn .92

PLANTS 104

Succulent. 105

Cactus. 110

Rose . 114

Cherry Blossom . 120

BEADS 124

About the Artist .128

INTRODUCTION

I remember the day I discovered polymer clay. This was before video tutorials became so accessible, and search engines were still working out their kinks. I found a Japanese website with a simple image gallery full of tiny, realistic-looking foods arranged in various scenes, and I fell in love. The next day, I went to my local art and craft store and picked up a couple of packs of clay.

My first pieces were not pretty. They honestly weren't much more than lumps of reddish-brown clay meant to look like loaves of bread, but I didn't let that deter me. I made things because it was fun, and over many years, I came to develop a style and techniques of my own.

In this book, I hope to share some of the things I've learned and inspire you to make some wonderful creations of your own.

Let's get started!

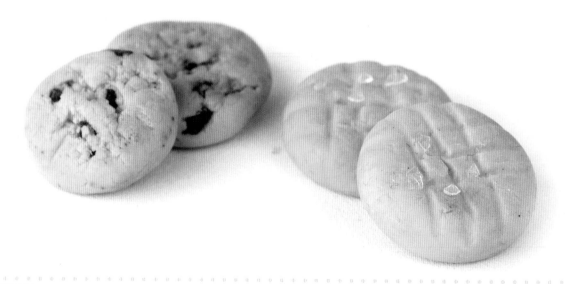

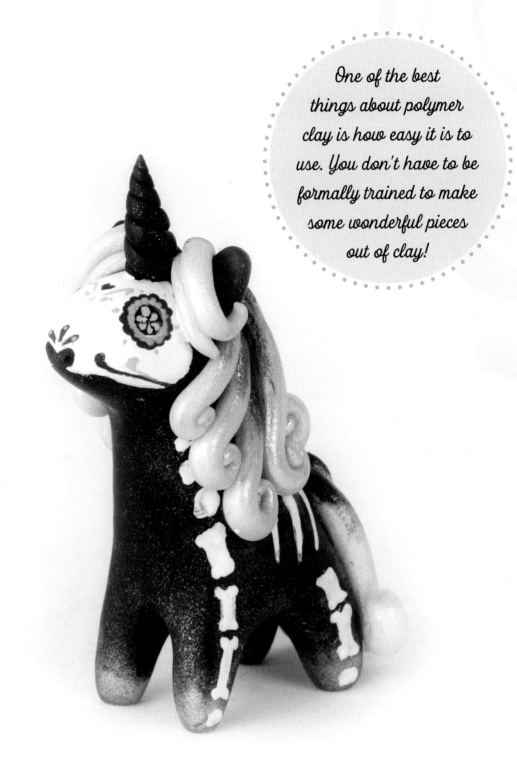

One of the best things about polymer clay is how easy it is to use. You don't have to be formally trained to make some wonderful pieces out of clay!

TOOLS & MATERIALS

One of the things I love most about working with polymer clay is that it's possible to make amazing creations using only your hands. However, having a few additional tools will make your polymer clay projects easier to accomplish. We'll discuss them here, along with the different types of clay that can be used.

POLYMER CLAY

Let's start by exploring your main material, clay, which is available in art and craft stores and online. Polymer clay comes in different brands and colors and varies widely in durability and ease of use.

Some of the types of clay you may find at your local craft store include Original Sculpey®, Sculpey® III, Premo! Sculpey®, FIMO®, and Kato Polyclay™. I like to use Premo and FIMO, and all of the projects in this book are made using these two brands. However, there is no one "best" brand, so the clay you choose will depend on the purpose and project you're working on.

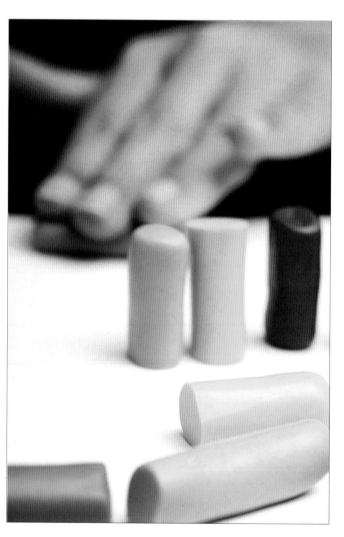

TIP ○ ○ ○ ○ ○ ○ ○ ○ ○ ○ ○ ○

When purchasing clay in a store, you might want to try feeling the clay to ensure its workability and softness. Some brands start off quite hard and require more kneading.

ADDING COLOR

Polymer clay comes in many wonderful, vibrant colors, but it also provides a good base for adding colors using materials like chalk pastels and water-based acrylic paints.

LIQUID POLYMER CLAY

Polymer clay in liquid form is more flexible than regular polymer clay. It can be used to embellish or seal clay pieces and is baked the same way as regular polymer clay.

TIP

- Use chalk pastels on your clay prior to baking to add soft, subtle color to your piece.

- Acrylic paints can be used to add detail to clay after baking.

- Various-sized brushes allow you to create different levels of detail.

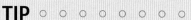

DETAILING

Although you really only need your hands for working with clay, having a few basic tools can make things a lot easier. A sharp blade, a needle, and a round-tipped tool (a ball stylus) can make all the difference when it comes to adding details.

These can all be found in craft stores and online. If you prefer to use tools you already have on hand, alternatives include toothpicks, razor blades, and sewing pins.

ROLLING & SHAPING

If you decide to make any kind of investment in equipment, I recommend purchasing a pasta machine. Not only does it make rolling sheets of clay easier, but you can also use it to mix colors and take some of the strain off your hands.

Some polymer clay manufacturers make these devices, but a hand-crank pasta machine works just as well. Just remember to use it only for clay!

TIP ○ ○ ○ ○ ○ ○ ○ ○

A hand roller or rolling pin works too if you don't have a pasta machine, and shape cutters can be used to create interesting pieces.

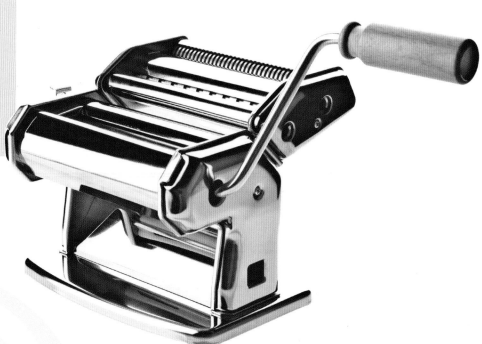

JEWELRY-MAKING SUPPLIES

Being able to wear and use your creations is one of the most exciting parts of making art with polymer clay! Some jewelry-making supplies you might want to pick up include head pins, eye pins, earring hooks, earring posts, and rings. Needle-nose and round-nose pliers and a pair of flush wire cutters are necessary for working with wire supplies.

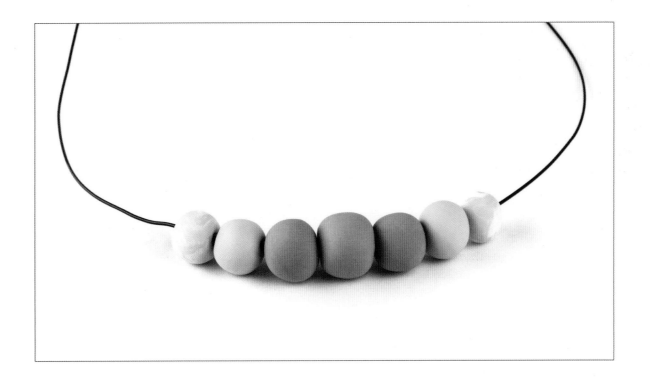

TECHNIQUES

Many techniques can be used to form polymer clay into a wide variety of objects, from food items to plants and animals. In this book, we'll explore a handful of the simplest and most useful techniques, including caning, texturing, and blending colors.

Let's start by learning about some of the basic shapes you will need to make when working on the step-by-step projects in this book.

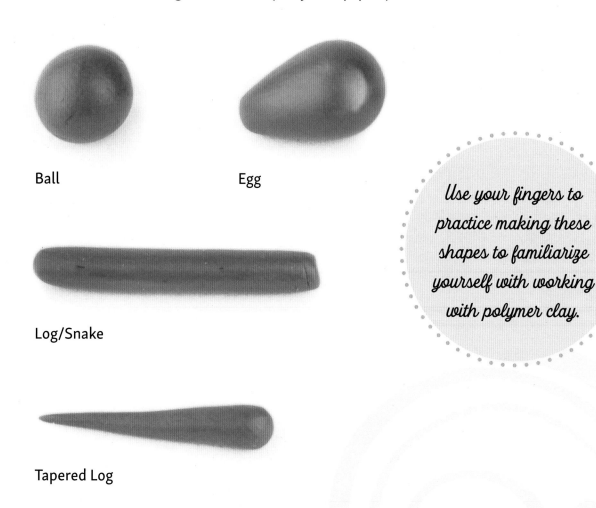

Ball

Egg

Log/Snake

Tapered Log

Use your fingers to practice making these shapes to familiarize yourself with working with polymer clay.

MIXING COLORS

Some of the projects in this book instruct you to mix two colors together to create another color or a smooth transition between colors. You'll want to create a seamless blend, and it's important to know how to do that, starting with something called the "Skinner Blend." A common technique, this blend results in beautiful gradients that can be made using any combination and number of colors. Let's learn how to do it.

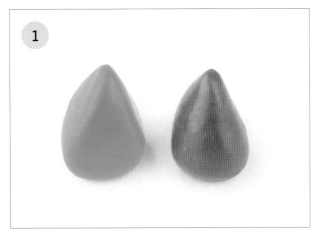

Choose 2 colors of polymer clay, and form each into a teardrop shape.

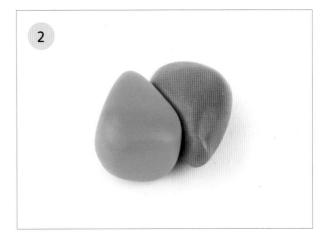

Place the shapes together.

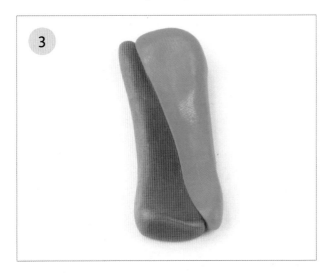

Flatten the pieces to combine and create a strip.

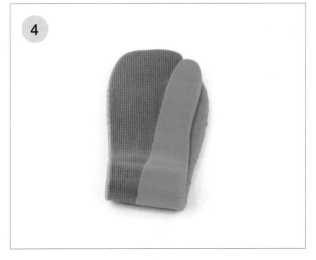

Fold the strip over, keeping the two alike colors together. Run the mixture through the largest setting of a pasta machine, or use a rolling tool to roll the strip to about ⅛" (3 mm) thick.

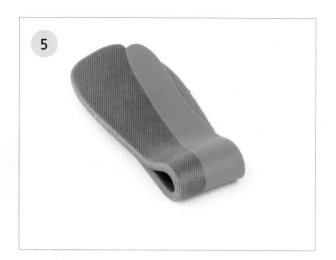

Flatten and repeat.

Repeat these steps about 10 times. Your piece should look like this when you're done.

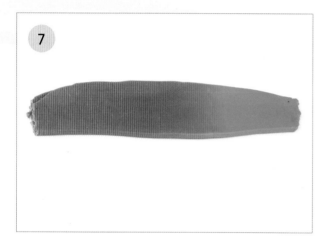

Continue folding and flattening another 10 to 15 times.

Once you have a smooth gradient, run the clay through your pasta machine or use a roller to create a long strip. Now you have two options for completing your gradient.

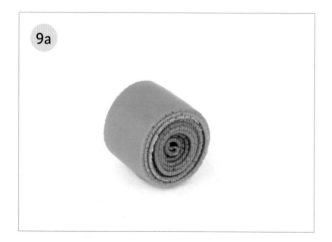

Option A: You can create a log by rolling up the strip.

Roll out the log to thin and lengthen it. Now you can slice off pieces as you need them.

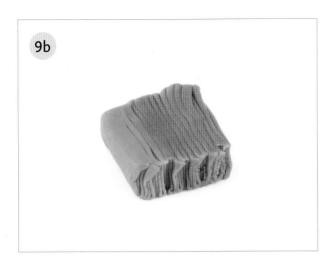

9b

Option B: Alternatively, you can fold up the strip into a small block.

Flatten out the block and slice off pieces to use.

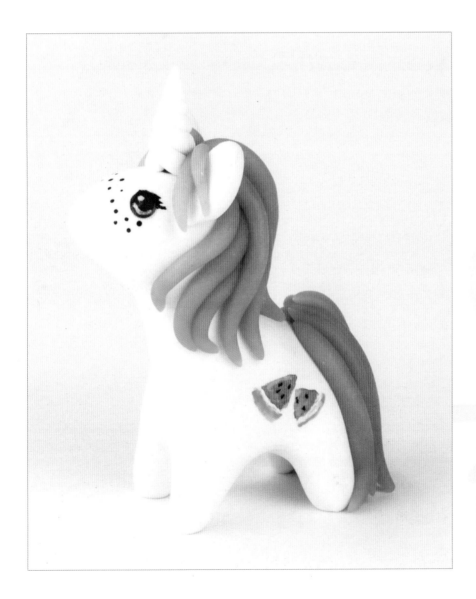

I made this unicorn's lovely mane using the second finishing technique (9b; see above).

BAKING GUIDELINES

Baking times and temperatures may vary depending on the brand of clay you use. Often, the specific temperature will depend on the clay's thickness.

Below are some brand-specific baking guidelines. You can follow these as you work on the projects in this book. Each time listed is per ¼" (6 mm) of thickness.

Keep in mind that you should experiment with different times and temperatures to determine what works best with your oven. You can try to lower the oven temperature and bake your clay longer, but do not exceed the temperature listed on the packaging.

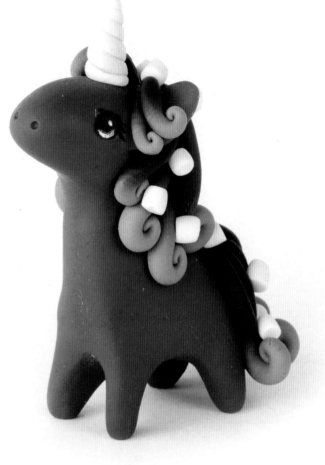

BRAND	BAKING TEMPERATURE	BAKING TIME (per ¼" of thickness)
Premo! Sculpey®	275°F (130°C)	30 minutes
Sculpey® III	275°F (130°C)	15 minutes
FIMO®	230°F (110°C)	30 minutes

BAKING TIPS

Although polymer clay is nontoxic and can be baked in a regular oven, you may choose to invest in a dedicated toaster oven.

TIP ○ ○ ○ ○ ○

Cover your pieces of clay with foil to prevent scorching while baking.

Working on a ceramic tile (these are sold at hardware stores) will enable you to bake your clay directly on the tile without moving and risking ruining your piece. Ceramic tile can turn the bottoms of your pieces shiny, but placing a sheet of scrap paper underneath the clay prevents this.

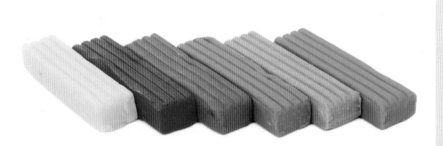

TIP ○ ○ ○ ○ ○ ○ ○ ○

Noticing cracks in your clay? Try starting with a cold oven and set the timer when the oven has reached your desired temperature.

If using different brands of clay that come with various baking instructions, always use the lowest of the recommended temperatures. It's fine to bake polymer clay at a slightly lower temperature for more time.

TROUBLESHOOTING TIPS

When you bake your polymer clay pieces, there are a few things that can go wrong. Don't worry, though—we're here to help! Here are some common problems you might face, as well as how to fix them.

BURNED CLAY

You'll know you've burned your clay if it comes out blackened, darkened, and/or shiny. If this happens, the next time you bake your clay, lower the oven temperature by 10 degrees and cover your clay with aluminum foil or a foil baking pan to protect the clay from the oven's heating element.

TIP ○ ○ ○ ○ ○ ○ ○ ○ ○ ○ ○

When you place a clay piece in the oven, situate it in the center, as far from the heating element as you can, to allow air and heat to circulate around the clay. This will help prevent burning.

UNDERBAKED CLAY

Underbaked clay will appear raw or feel squishy. An advantage to polymer clay is that you can bake the same piece multiple times without ruining it, so if your clay comes out underbaked, simply bake it again for the length of time recommended on the package of clay. If your piece still doesn't harden, raise the oven temperature by 5 to 10 degrees.

CRACKS

If you pull your piece out of the oven and notice cracks in the clay, all is not lost! If the clay still feels warm, quickly squeeze together the crack and hold it under cold water for 1 to 2 minutes. If your piece is cold, put it back in the oven to heat it up, and then try the cold-water method. Alternatively, you may be able to fill the crack by smoothing a bit of clay over it and baking for another 5 to 10 minutes.

FINISHES

Polymer clay is very durable (it's made from PVC, or polyvinyl chloride; plasticizer; and pigment) and hardens after baking. Sealing it isn't necessary, but you can add different finishes to help preserve your pieces.

Finishes come in everything from matte or semi-glaze to shiny glaze. Ultimately, the type of finish you choose comes down to personal preference. For instance, you may want to use a shiny glaze on a slice of fruit to make it look wet, or you can add a matte finish to protect the details painted onto an animal.

Most major polymer clay manufacturers make glazes that are sold in craft stores. A water-based polyurethane finish, found in hardware stores, may also be used.

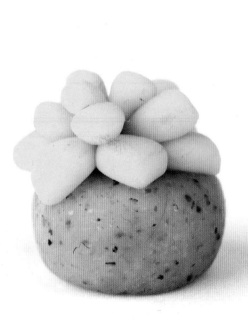 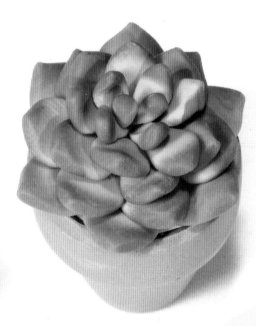

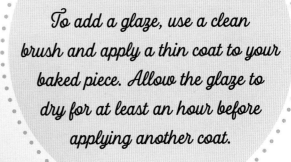

APPLYING A GLAZE

To add a glaze, use a clean brush and apply a thin coat to your baked piece. Allow the glaze to dry for at least an hour before applying another coat.

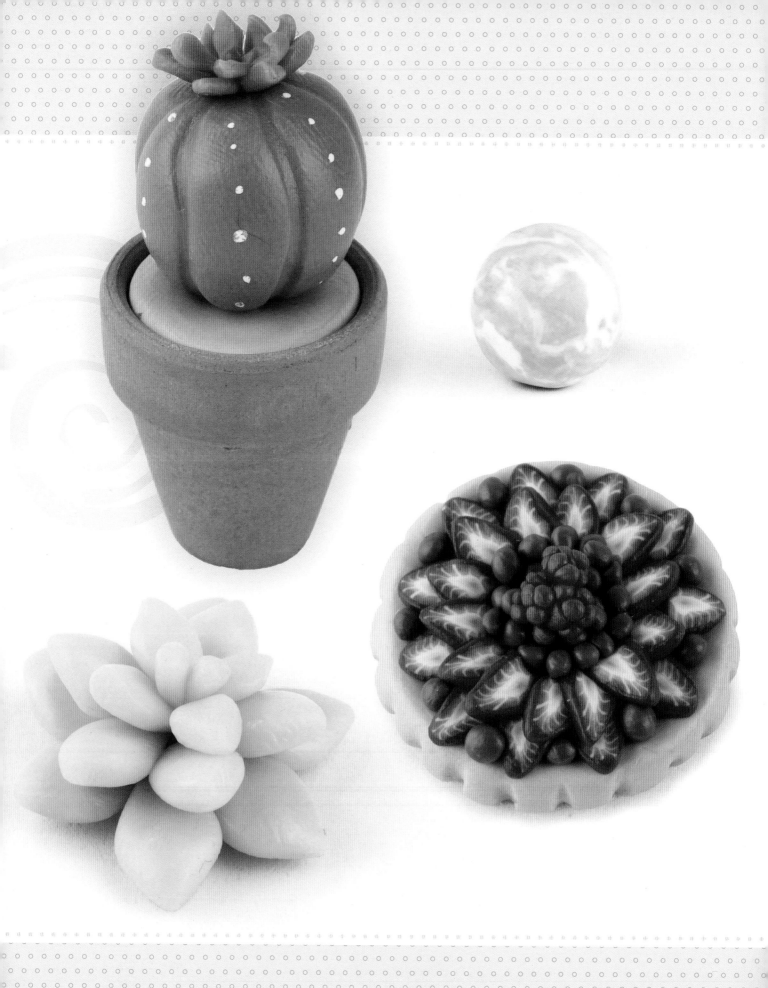

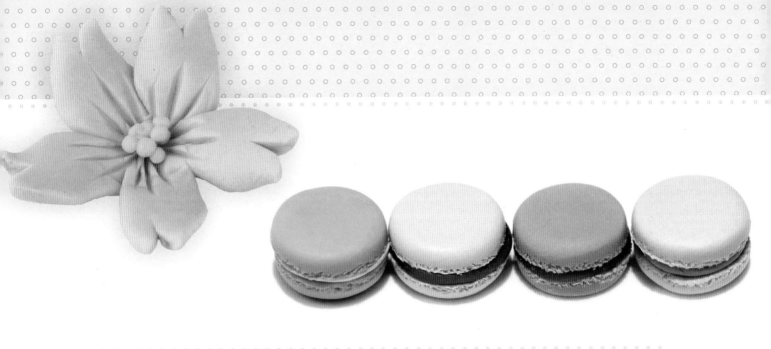

PROJECTS

FOOD

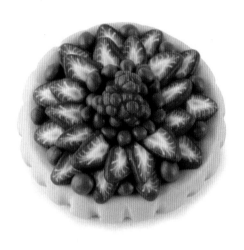

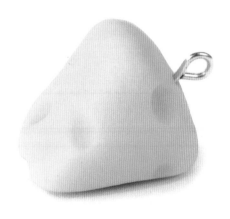 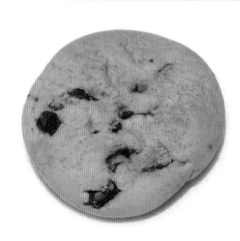

MACARON

A macaron is a sweet treat popularized in France that now appears all over the world. What's your favorite flavor of macaron? Let's learn how to make it using polymer clay!

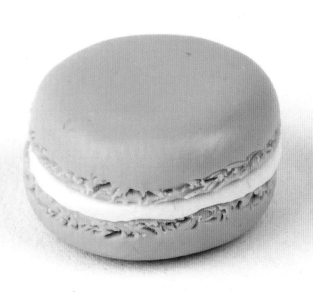

TOOLS & MATERIALS

- Polymer clay in light green and white translucent
- Rolling tool
- Circle cutter
- Pointed detail tool or sewing pin

STEP 1

Separate the green clay into two balls, making one of the balls about one-quarter the size of the other. Form the translucent clay into a ball the same size as the smaller green one.

Then mix the small balls of translucent and green clay together.

STEP 2

Use a rolling tool to flatten the clay mixture to about ⅛" (3 mm) thick. With a round cutter, cut out two small circles.

STEP 3

Using a pointed detail tool or sewing pin, lightly swirl the sides of the circles to add texture.

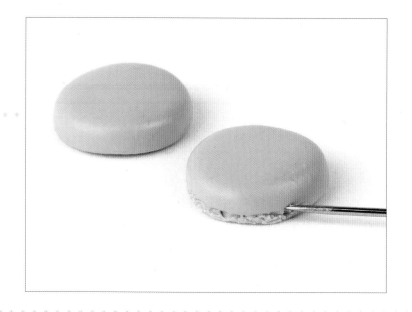

STEP 4

Continue swirling all around the edges of the two circles.

Then use a roller to flatten out the light green clay to about half the thickness of the other circles. Place the light green clay in the center of the macaron halves, with the textured sides facing the center.

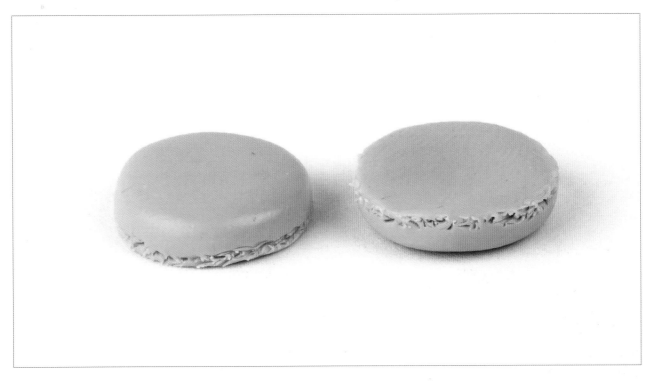

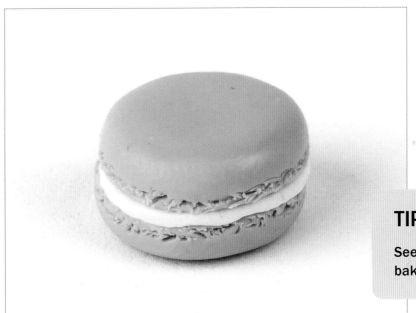

STEP 5

Bake in the oven according to the instructions on the package of clay to finish making your delicious French macaron!

TIP ○ ○ ○ ○

See pages 16–17 for baking guidelines.

CHOCOLATE CHIP COOKIE

I love chocolate chip cookies, and these make a fun, easy project for beginners!

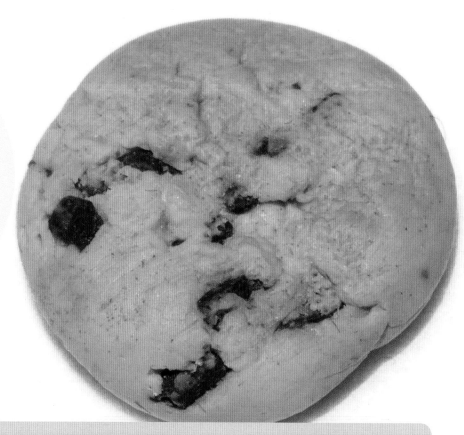

TOOLS & MATERIALS

- Polymer clay in ecru or tan, translucent, and dark brown
- Rolling tool or pasta machine
- Sharp edge or blade cutter
- Tan and red-brown chalk pastels
- Toothbrush

STEP 1

Start with a 1:1 ratio of ecru and translucent clay. Mix until thoroughly combined and set aside.

STEP 2

Roll out a thin sheet of dark brown clay, and then bake it in the oven for about 5 minutes to harden. Let the clay cool.

STEP 3

Use a sharp tool to chop the sheet into chunks.

STEP 4

Flatten the ecru-translucent mixture from step 1, creating a disc. Place the chunks from step 3 onto the disc, and mix to distribute evenly.

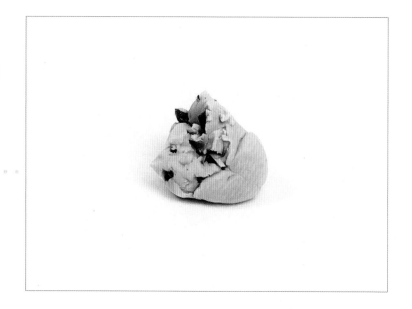

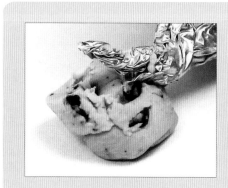

TIP ○ ○ ○ ○ ○ ○ ○

Use a rolled-up piece of aluminum foil to add texture to the cookie by pressing down randomly across the clay.

STEP 5

Use your fingers to press up the edges of the cookie and create a round shape.

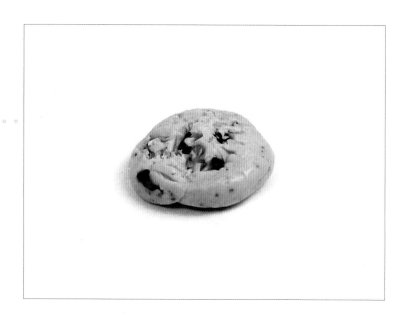

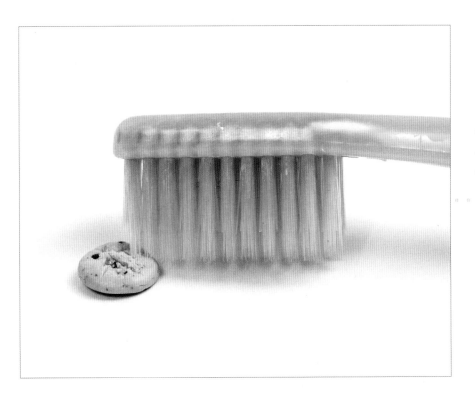

STEP 6
With a clean
toothbrush, add more
texture to the cookie.

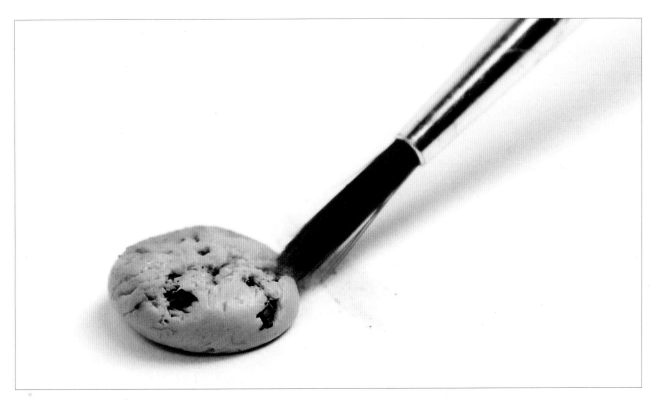

STEP 7
Shave some tan and red-brown
chalk pastels using a sharp blade.
Then brush the tan chalk pastels
all over the cookie.

STEP 8

Brush red-brown chalk pastels onto the raised parts of the cookie.

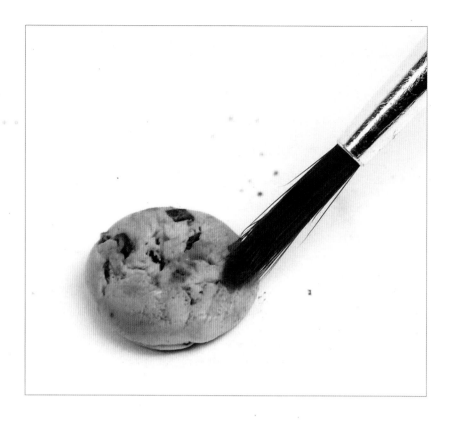

STEP 9

Follow the baking instructions on the package of clay, and now you've made a delicious little chocolate chip cookie!

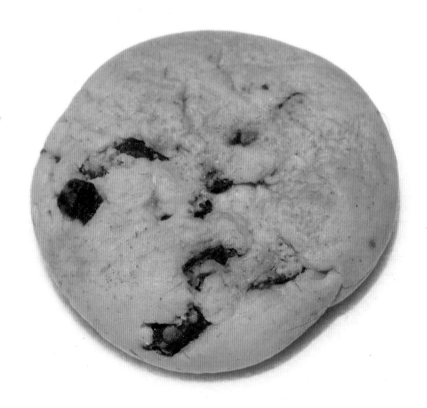

FRUIT CANES

In addition to making three-dimensional pieces like the ones you've already seen in this book, you can try combining two or more colors of clay into a single rod. Cutting the rod into slices creates a two-dimensional pattern that's ideal for making flowers, jewelry, and buttons. This rod is called a "cane," and here, we'll use this technique to create slices of fruit, starting with an orange and then moving on to a strawberry. The slices can be used to garnish the fruit tart on pages 42–45.

ORANGE SLICES

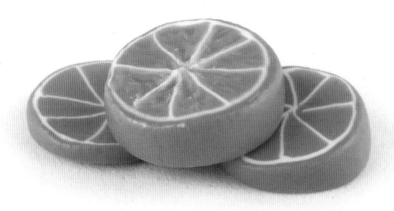

TIP ○ ○ ○ ○ ○ ○ ○

You can use these juicy orange slices as earrings, dollhouse miniatures, or home décor! Change up the colors to create different types of citrus fruits, such as lemons or limes.

TOOLS & MATERIALS

- ○ Polymer clay in translucent, orange, and white
- ○ Blade tool
- ○ Rolling tool
- ○ Toothpick or small, round detail tool

STEP 1

Start with equal parts of translucent and orange clay, and mix the two together. Then shape your clay into a thick wheel.

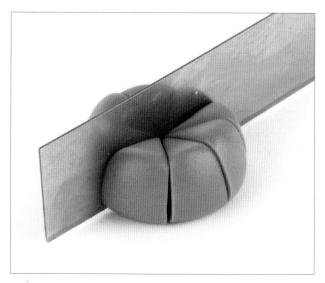

STEP 2

With the blade tool, slice the wheel into 8 equal parts, and set them aside.

STEP 3

Use a roller to roll out a thin sheet of white clay.

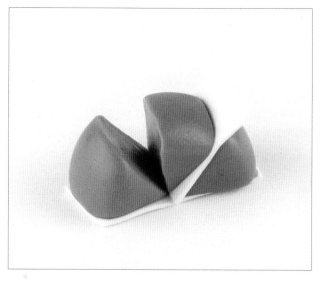

STEP 4

Cut a strip of white clay the same width as your orange slices, and lay three of the orange slices on top as shown. Trim off any excess clay.

Cut another strip half the length of the first, and place it between two orange slices.

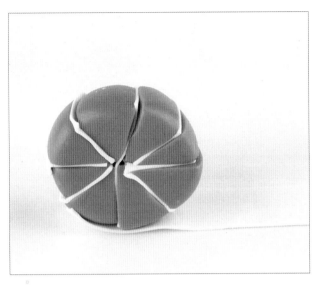

STEP 5

Continue adding slices of white clay all the way around your orange wheel. Then cut a strip of white clay to cover the sides of your orange wheel.

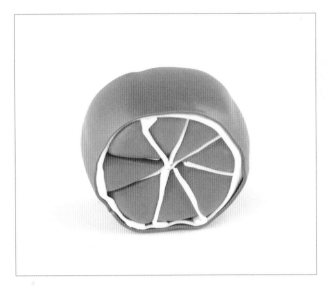

STEP 6

Wrap the white clay around the orange wheel and cut off any excess. Repeat, using orange clay this time.

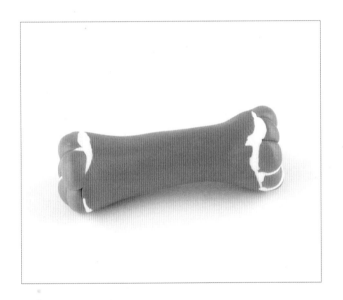

STEP 7

Using your fingers, pinch, roll, and pull the orange wheel to create a log.

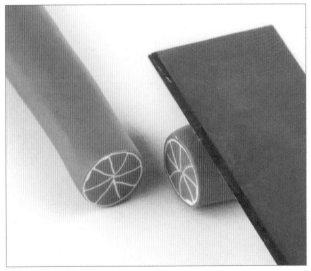

STEP 8

Use your blade tool to cut a few slices from the log.

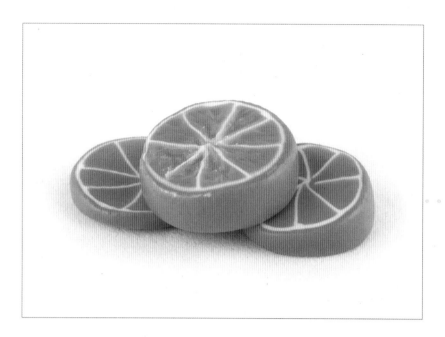

STEP 9

Leave the orange slices as they are, or use a toothpick or round detail tool to poke the orange flesh and add texture. Then bake according to the directions on the package of clay.

STRAWBERRY SLICES

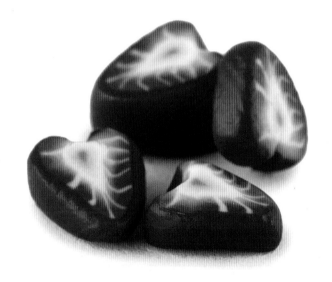

TOOLS & MATERIALS

- Polymer clay in white, translucent, and red
- Rolling tool
- Blade tool
- Optional: toothpick

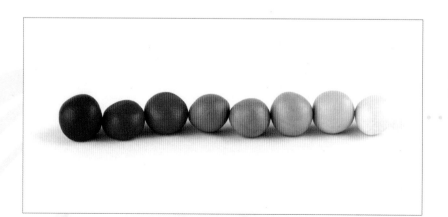

STEP 1

Mix together 8 balls of clay, gradated from red to translucent white, as shown.

STEP 2
Using the third-lightest pink color, form a teardrop shape. Pinch its sides to make it thicker and more blocklike.

STEP 3
With the next-lightest shade, form a thick strip, and wrap it around the teardrop shape. Pinch or roll the clay on a flat surface to bind the colors.

STEP 4
Repeat step 3 with the lightest color you mixed.

STEP 5

Pinch and pull the clay to form a thick log. This will be the center of the strawberry. Set it aside for now.

STEP 6

Reserving the red clay, shape the four remaining pink colors into thick rectangles. To mix the colors, we'll use the Skinner Blend technique, which is described on pages 13–15.

Stack the rectangles, and press to flatten them.

STEP 7

Use a rolling tool to create a long strip of these 4 colors. Fold the strip over, placing the two alike colors together, and roll and flatten again.

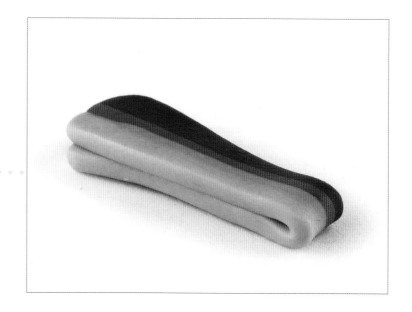

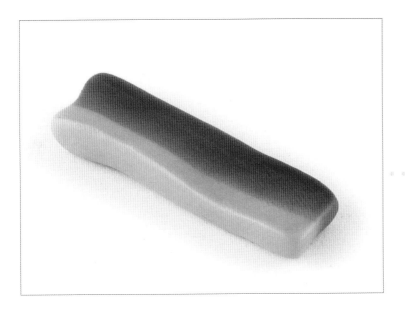

STEP 8

Fold and roll your clay mixture about 15 to 20 times to create a smooth gradient. Shape the finished gradient into a long rectangle.

STEP 9

Use your blade tool to cut the rectangle into 12 equal pieces. Then roll out a thin strip of white clay.

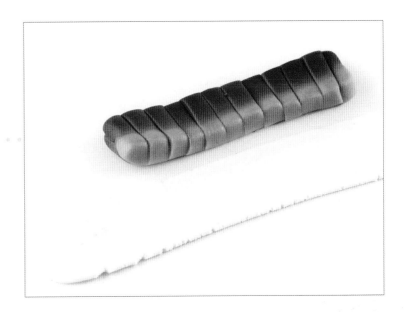

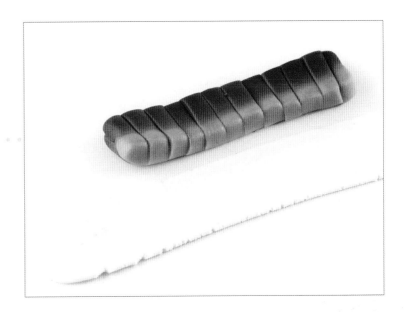

STEP 10

Cut a piece of white clay to fit between two of the slices, with the end hanging out. Fold the white clay to one side. Repeat with all of the slices.

STEP 11

Cut a strip of white clay the length of the entire rectangular shape, and place it along the side of the rectangle. Wrap the outer layer around the center layer of the strawberry.

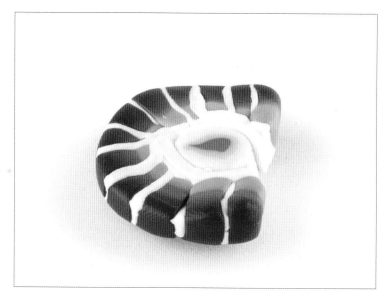

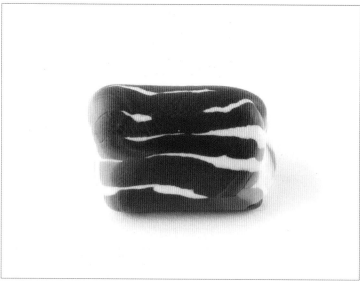

STEP 12

Squeeze and pull the rectangle to combine the layers.

STEP 13

With the red clay that you reserved, roll out a thin layer, and wrap it around the strawberry cane. Pinch and pull, maintaining a rounded triangle, until you've created a long cane.

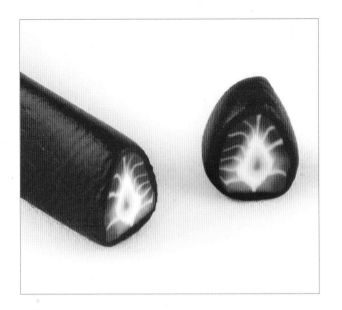

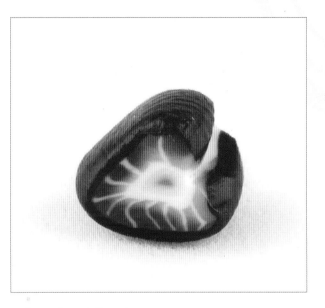

STEP 14

Cut into the center of your cane to find the most even-looking area. It's normal for the ends of the cane to look a bit squished or warped; you can fix their shape if necessary.

Then use a blade tool to slice the cane.

STEP 15

Use a toothpick or your finger to slightly round the bottom of each slice.

STEP 16

Bake the strawberry slices in the oven according to the instructions on the package of clay.

FRUIT TART

Now, let's use the cane techniques we went over on pages 33–41 to make a beautiful fruit tart! You'll need to create a strawberry cane like the one on pages 36–41 before you begin.

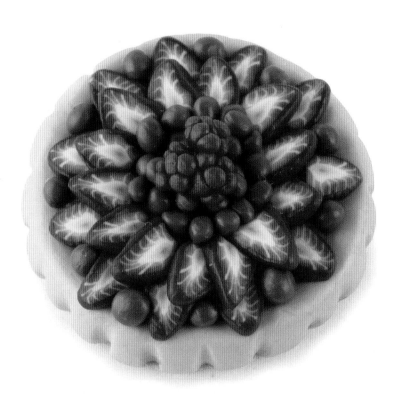

TOOLS & MATERIALS

- Strawberry cane (see pages 36–41)
- Polymer clay in tan, light tan, red, and dark blue
- Toothpick
- Blade tool

STEP 1

Use the tan clay to form a flat disc for the tart shell. With a toothpick, score the sides of the disc.

STEP 2

With your thumb, create a slight dip in the tart shell. Form a disc of light tan clay, and fill the dip in the shell.

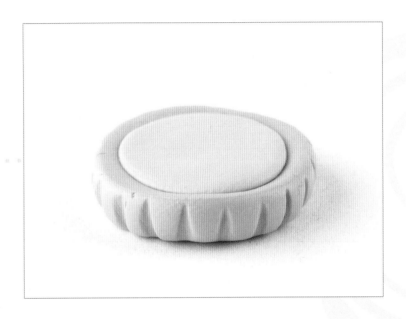

STEP 3

Use the dark blue clay to form many tiny blueberries. Don't worry if their sizes vary; real blueberries come in different sizes too!

STEP 4

Roll the red clay into tiny balls. Roll together about 8 to 10 balls to form a raspberry. Each raspberry should be slightly larger than the blueberries; make 3 of them.

STEP 5

Use your blade tool to slice the strawberry cane. You'll need about 12 strawberry slices.

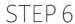

STEP 6

Arrange the first row of fruit around the edge of the tart, alternating the strawberries and blueberries.

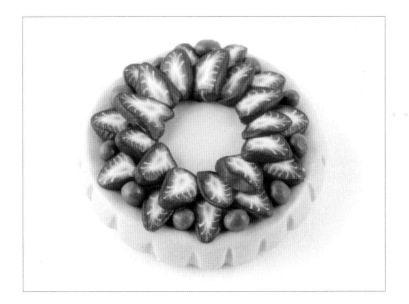

STEP 7

Moving inward, add another row of slightly overlapping strawberries.

STEP 8

Fill the empty space in the center with blueberries.

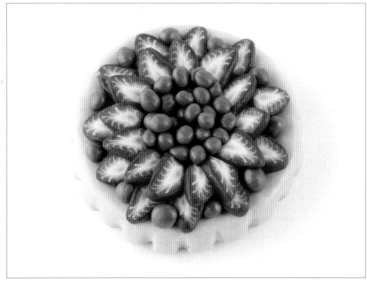

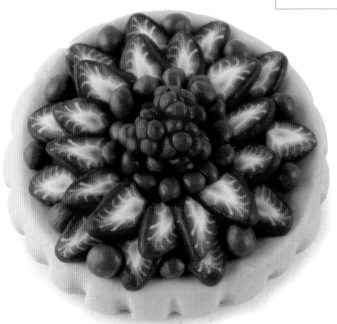

STEP 9

Place 3 raspberries on top of the blueberries. Bake according to the instructions on your package of clay, and now you've made a beautiful fruit tart!

RAINBOW CAKE

Who doesn't love cake?! This rainbow cake takes a bit of time to make, but the colorful result is stunning and well worth the effort!

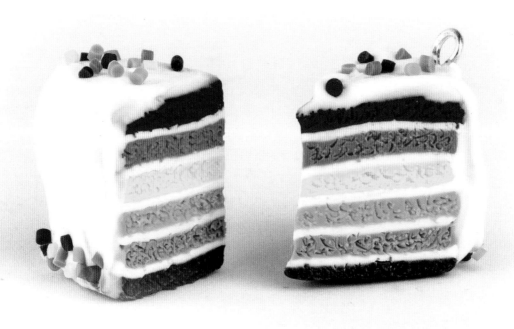

TOOLS & MATERIALS

- Small balls of polymer clay in white, red, yellow, orange, green, blue, and purple
- Rolling tool or pasta machine
- Circle cutter
- Cutting blade
- Pointed detail tool or sewing pin
- Liquid clay
- Flat modeling tool

STEP 1

With a pasta machine or rolling tool, roll out the colored balls of clay to ⅛" (3 mm) thick. Use a larger circle cutter to cut circles from the clay.

TIP ○ ○ ○ ○ ○ ○ ○ ○ ○

Don't have a pasta machine? No problem! Try using playing cards or index cards. Grab two piles of cards, place a rubber band around each of them, and then roll out your clay between the two stacks to create an even thickness.

STEP 2

Roll out a thin sheet of white clay to about one-quarter the thickness of the colored discs. Cut circles from the white clay, and place one on top of the purple disc. Then place the blue on top of the white disc, like a sandwich.

STEP 3

Continue placing layers of white clay between the colors to form a rainbow, ending with the red layer on top.

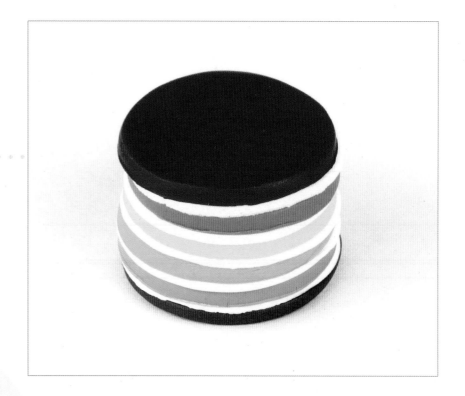

STEP 4
Using a straight cutting blade, cut the cake in half.

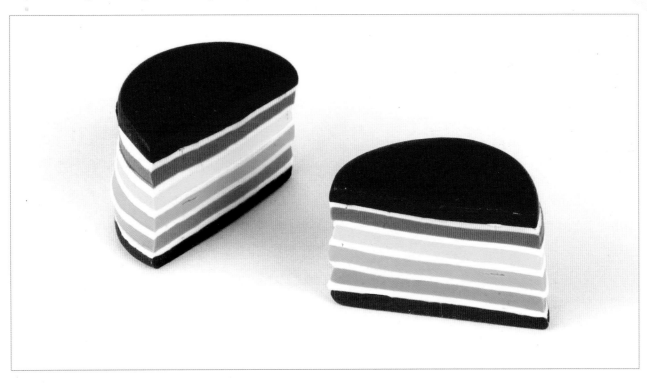

STEP 5
Cut the remaining pieces until you have formed 6 equal slices.

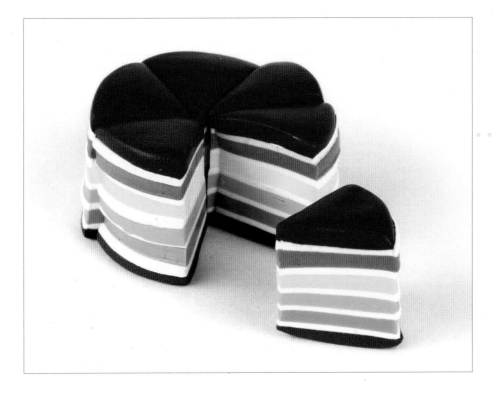

STEP 6

With a pointed detail tool or sewing pin, stir up the colored layers (except for the white) using small, circular motions. Clean the tool between each layer.

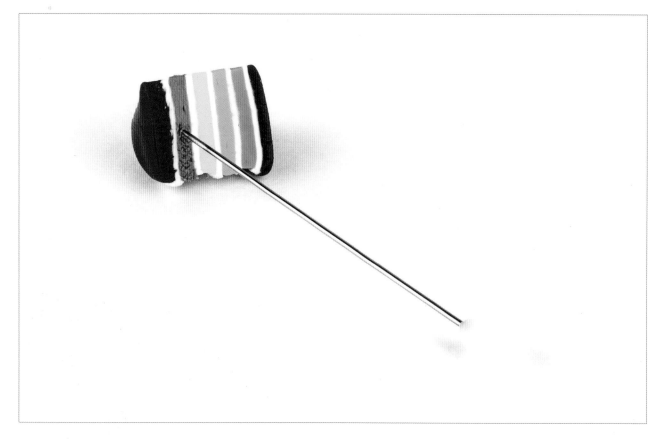

STEP 7

Continue texturing all of the layers. Bake the slices for about 5 to 10 minutes at the temperature indicated on the package of clay.

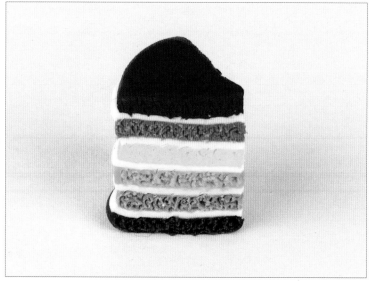

STEP 8

While you bake the cakes, prepare the frosting using equal parts white clay and liquid clay.

STEP 9

Mix with a flat tool until all the lumps are gone and you've formed a thick, sticky frosting.

TIP ○ ○ ○ ○ ○ ○

For more on liquid clay, see page 9.

STEP 10

Apply the frosting to the tops and sides of the cake slices.

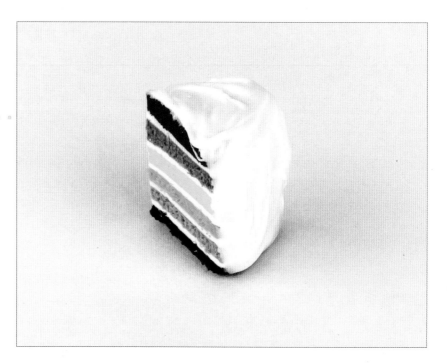

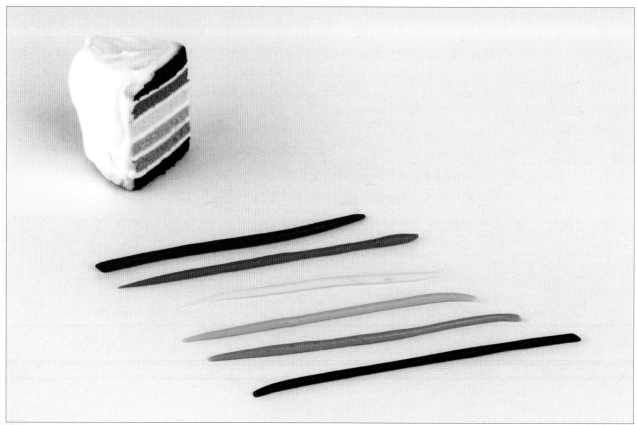

STEP 11

To make sprinkles, roll out a small snake of each color of clay, making each very thin. Bake the snakes for 5 minutes at the temperature indicated on the package of clay.

STEP 12

With a blade, cut "sprinkles" from the clay. Make them as small as possible while maintaining their circular shape.

STEP 13

Make about 10 to 15 sprinkles of each color.

STEP 14

Place the sprinkles on the tops and lower sides of the cakes.

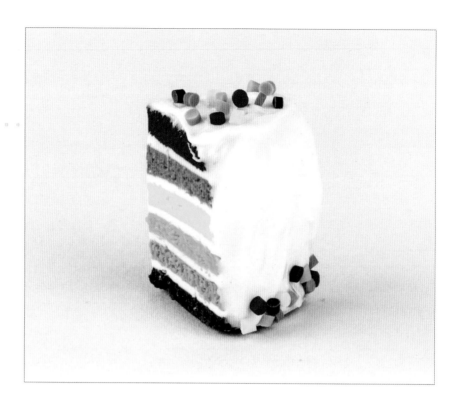

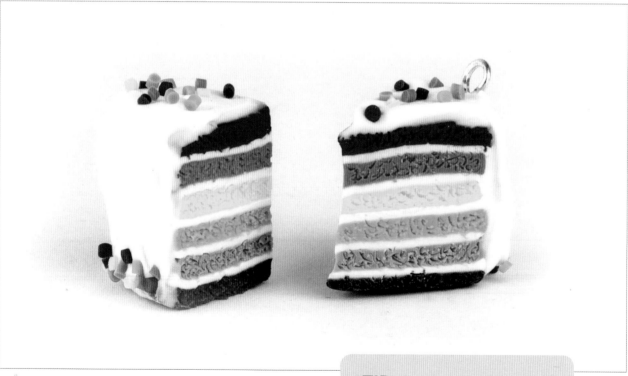

STEP 15

Bake the cakes for another 5 to 10 minutes, and they're done!

TIP ○ ○ ○ ○ ○ ○ ○ ○

Make your cake a charm by inserting a headpin! See pages 58–59 for instructions.

TIP ○ ○ ○ ○ ○ ○ ○ ○ ○

Try mixing different colors and decorations to create other kinds of cake. Leave the layers untextured if you're making mousse filling or a cheesecake!

SWISS CHEESE CHARM

This Swiss cheese charm looks delectable when hanging from a necklace, and it is so easy to make!

TOOLS & MATERIALS

- Polymer clay in yellow and translucent
- Large round detail tool
- Headpin
- Round-nose pliers

STEP 1

Form a small ball of yellow clay and a larger ball of translucent clay. Then mix the two together to create the shiny, transparent look of cheese.

Create a wedge by pinching the clay with your fingers and flattening it on your work surface.

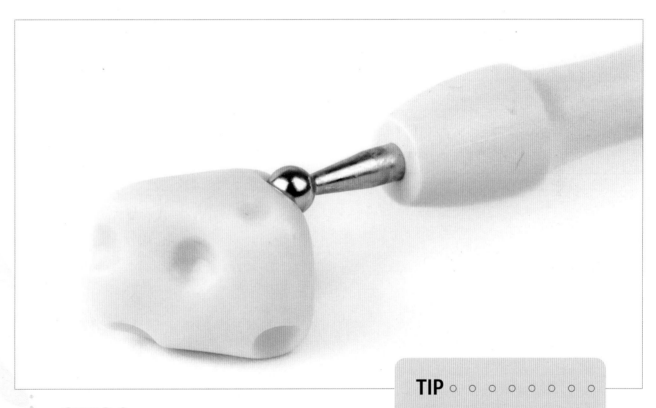

STEP 2

Using a large round detail tool, create the holes that are typical in Swiss cheese.

TIP ○ ○ ○ ○ ○ ○ ○ ○

If you don't have a round detail tool, try using the back of a paintbrush or a sewing pin to create the holes in Swiss cheese.

STEP 3

To turn the clay into a charm, carefully insert a headpin through the side of the wedge of cheese.

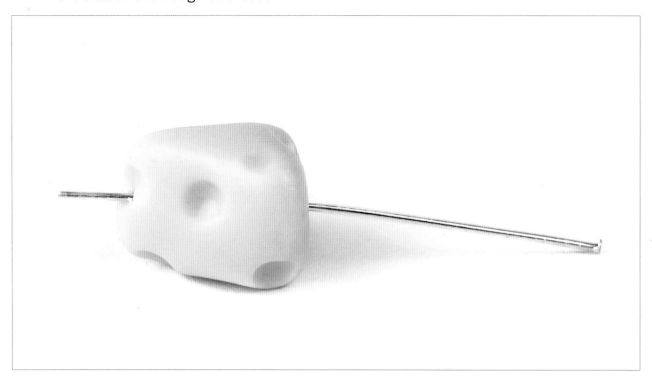

STEP 4

Leaving the headpin in the cheese, bake it in the oven according to the instructions on the package of clay.

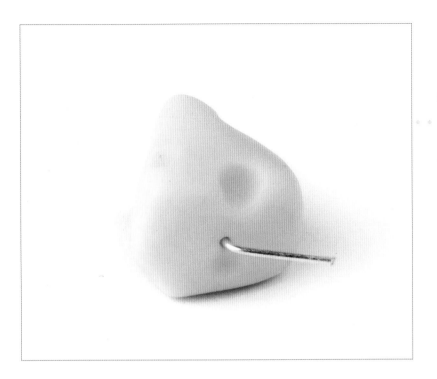

STEP 5

Let the clay cool. Then bend and cut the wire to about ¼" (6 mm) in length.

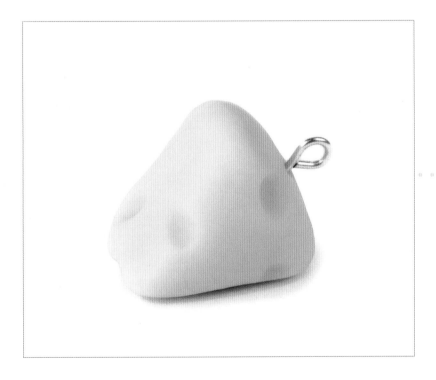

STEP 6

Using round-nose pliers, twist the wire into a small loop to finish your charm. Now you can carry a little wedge of cheese with you wherever you go!

ANIMALS

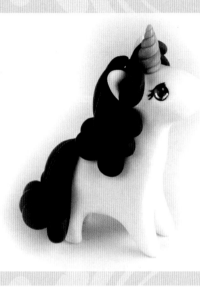

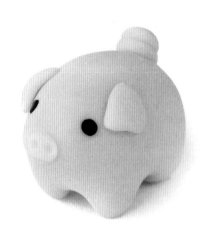

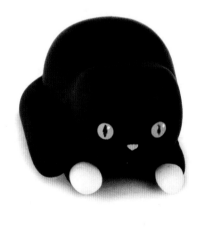

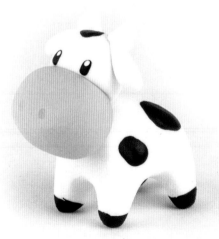

PUG CHARM

Whether you're a dog person or more of a cat person, this little Pug is sure to bring a smile to your face.

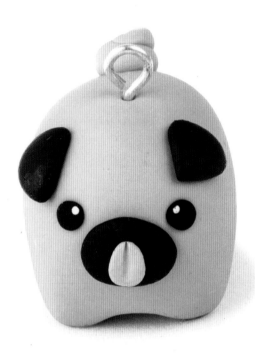

TOOLS & MATERIALS

- Polymer clay in tan, black, and pink
- Round detail tool
- Headpin
- Acrylic paint in white and black

STEP 1

Form the tan clay into a ball, and then use the side of your finger to create an indent for the Pug's legs.

STEP 2

Pinch each corner slightly to pull out the legs.

STEP 3

Turn the Pug right side up to make sure it stands evenly, and adjust as needed. Roll out a thin rope of tan clay that's roughly the same length as the Pug's body.

STEP 4

Coil up the rope to create a curly tail. Place it on the Pug's backside, and smooth down one end of the tail to attach it firmly to the body.

STEP 5

Using black clay, create a small oval disc. Place it in the center of the Pug's face for its muzzle.

STEP 6

Make two small black triangles for the Pug's ears. Place them on either side of its face, above the muzzle.

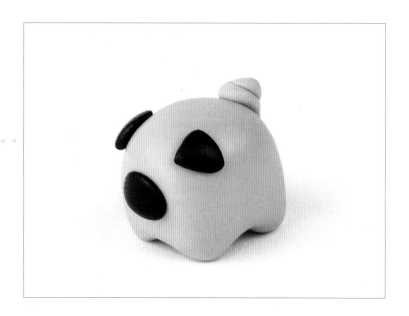

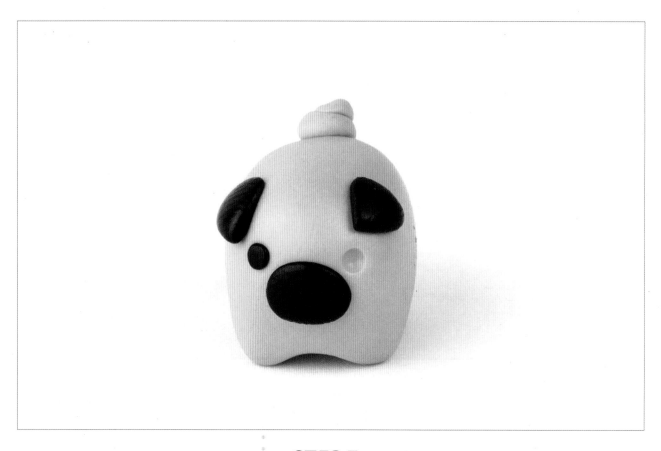

STEP 7

Using a round detail tool, make indents where you want the Pug's eyes to go. Form two tiny balls of black clay, and place them in the indents. Flatten them with your finger.

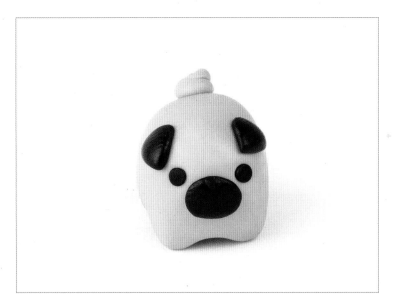

STEP 8

Make a small black triangle about the same size as the eyes, and place it on top of the muzzle to form the Pug's nose.

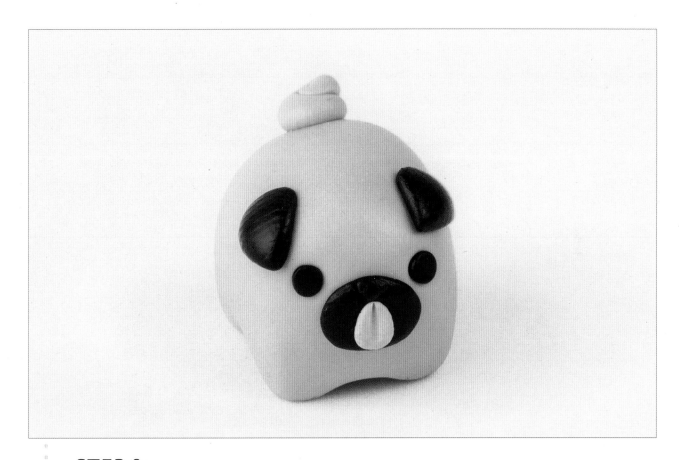

STEP 9

With a small amount of pink clay, make a flat oval for the dog's tongue. Use your fingernail or a needle tool to create a line in the tongue, and place it on the muzzle with the end of the line touching the Pug's nose.

STEP 10

To turn your Pug into a charm, carefully push a headpin through the top, and then bake it according to the instructions on the clay's packaging.

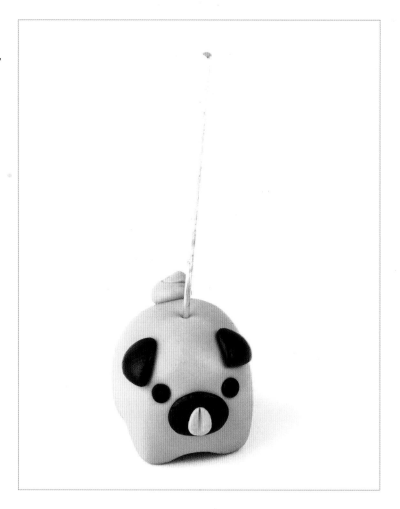

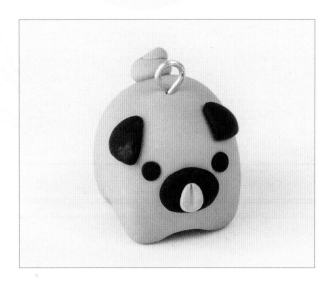

STEP 11

Once baked and cooled, bend and cut the wire to about ¼" (6 mm) in length. Then use round-nose pliers to twist the wire into a small loop.

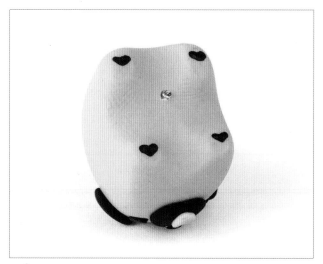

STEP 12

Now let's paint your Pug's paws! Turn it upside down, and paint little black hearts with the points facing the front of the dog.

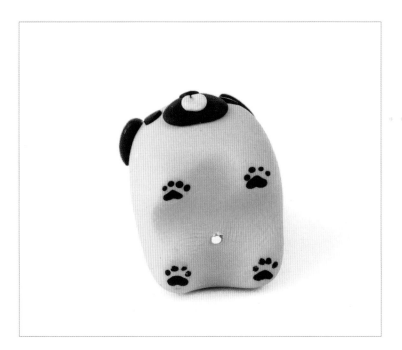

STEP 13

Paint four small ovals around the pointed end of each heart.

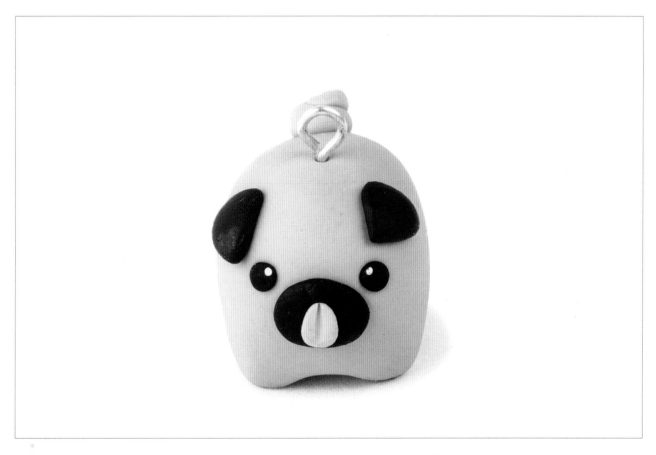

STEP 14

Finish up your polymer clay Pug by painting little white dots on the eyes. This will bring your dog to life!

CAT

Cats love to relax, and this little one is no exception! Try adding closed eyes for a cute variation on a sleepy kitty.

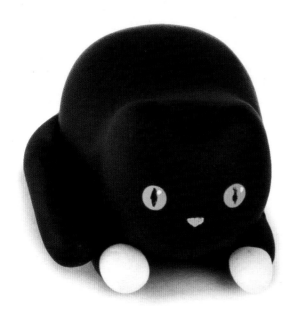

TOOLS & MATERIALS

- Polymer clay in black and white
- Acrylic paint in pink, green, black, and white

STEP 1

Form the black clay into a large egg shape.

STEP 2

Use your finger to press down the middle and make a bean shape.

STEP 3

On the larger end of the bean shape, create ears by pinching the two sides upward.

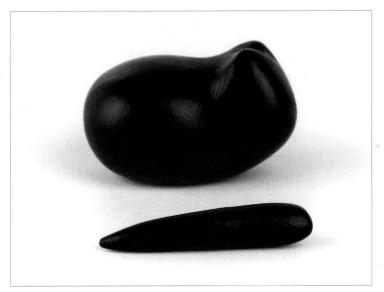

STEP 4

To create the cat's tail, form a tapered snake that's the same length as the body.

STEP 5

Attach the cat's tail to the body, and smooth down the area where the two meet using your finger.

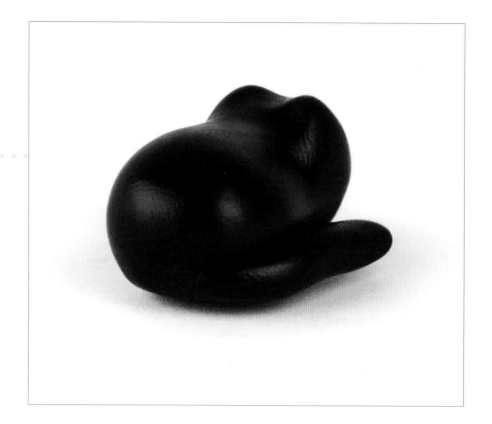

STEP 6

Curl the tail along the side of the body.

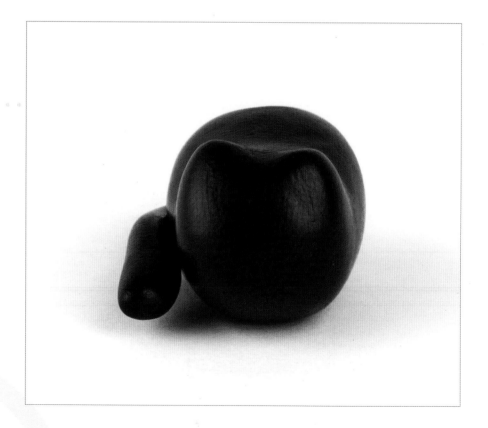

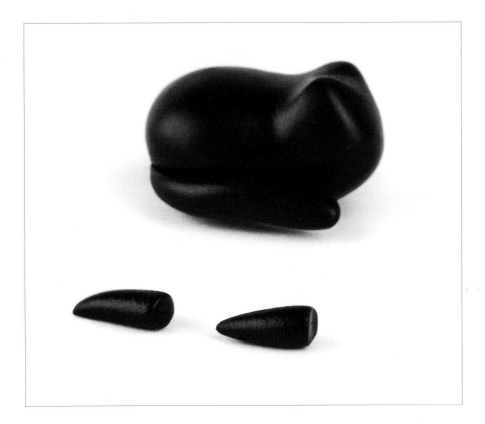

STEP 7

To make the cat's front legs, roll out two more tapered snakes that are half the size of the tail, and press to flatten each of the thicker sides.

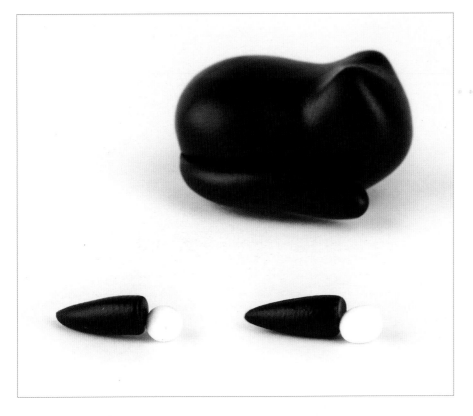

STEP 8

Form two small balls of white clay for the paws.

STEP 9

Place the white balls on the flat side of each leg, and gently roll to attach.

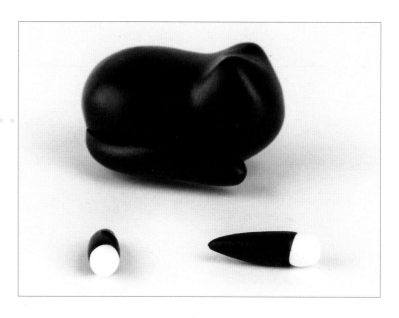

STEP 10

Place the arms on either side of the face. Bake according to the instructions on the package of clay.

STEP 11

Let the clay cool. Then paint a small, pink triangle in the center of the cat's face.

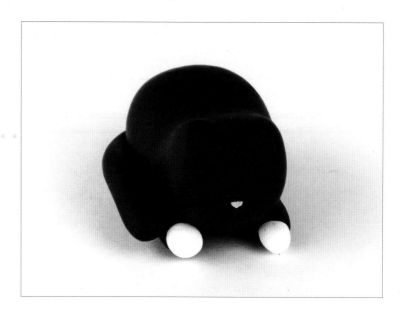

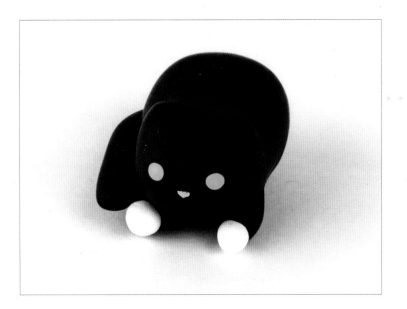

STEP 12
Paint two green circles for the eyes.

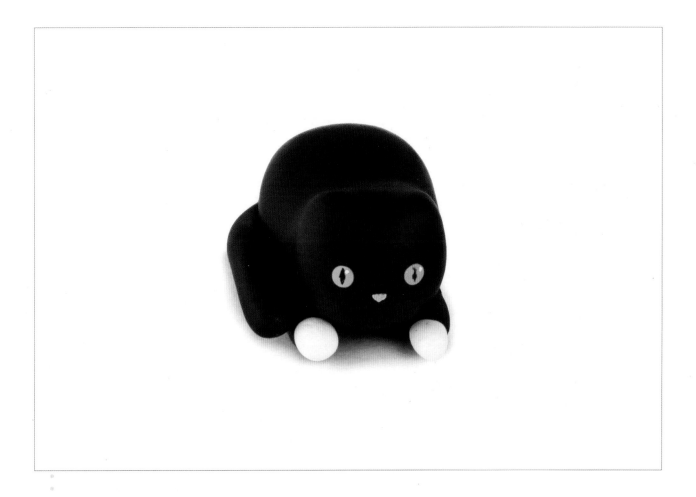

STEP 13
Add two black slits and white dots to the eyes to bring your little kitty to life!

ADD A BALL OF YARN

Now that you've created an adorable little black cat, why not add a ball of yarn for a fun pop of color?

STEP 1
Start with a disc of orange clay.

STEP 2
Roll out the disc into a long, thin snake.

STEP 3
Create a coil by wrapping the snake about 2 to 3 times around.

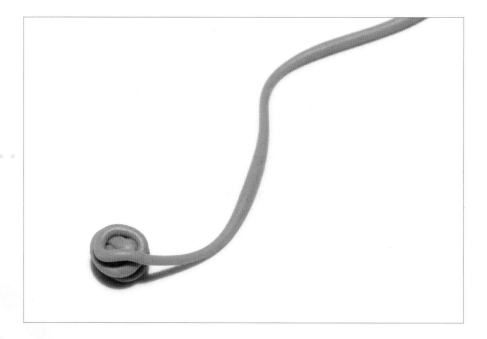

STEP 4

Turn the coil on its side, and wrap the snake perpendicularly.

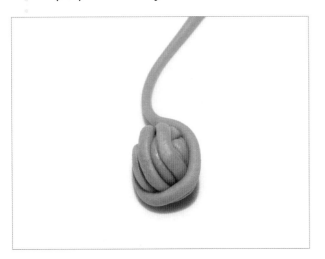

STEP 5

Turn the coil on its side again, and continue wrapping until you're happy with the size of the ball of clay.

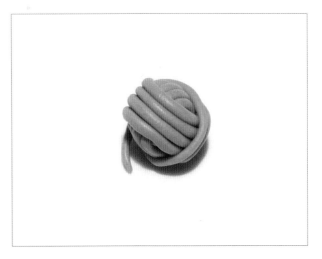

STEP 6

Position the ball of clay under one of the cat's paws, like he's playing with it. And you're all done!

PIG

Now let's make a pig that will *stay* tiny and cute!

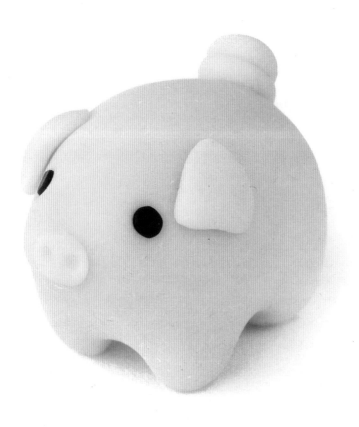

TOOLS & MATERIALS

- Polymer clay in light flesh pink or pink, and black
- Round detail tool or toothpick

STEP 1

Start by forming the pink clay into an egg shape.

STEP 2

At the narrow end of the egg, pinch and pull the clay slightly upward to create the pig's snout.

STEP 3

Squeeze the middle of the egg shape with the side of your finger. This indent will form the pig's legs.

STEP 4
Pinch the clay slightly to pull the legs out.

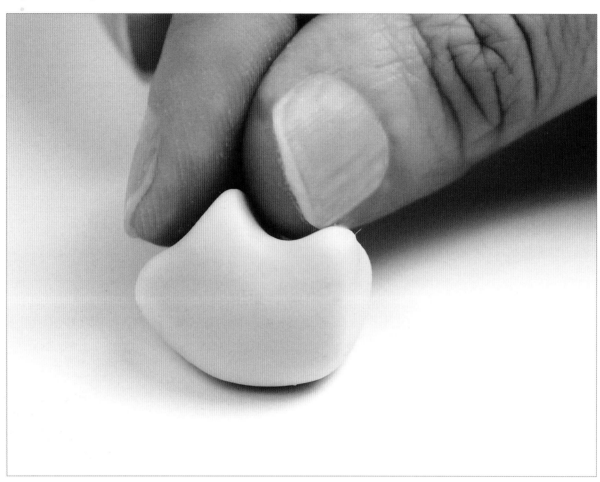

STEP 5
Pinch the clay again to begin creating individual legs.

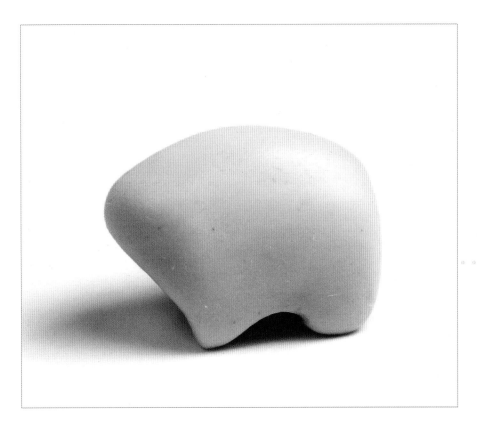

STEP 6

Repeat until you've created the pig's four legs. Then place the pig upright to check if it stands evenly. Adjust as needed.

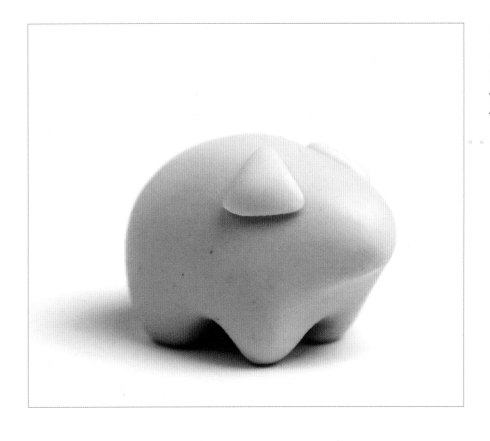

STEP 7

Form two small balls into triangles. Attach them to the pig's head to make its ears.

STEP 8

Make another small ball of light pink clay, and roll it out into a snake that's about the length of the pig.

STEP 9

Coil up the snake you just created to form the pig's curly tail.

STEP 10

Place the tail on the pig's backside. Then smooth down the bottom to firmly attach the tail.

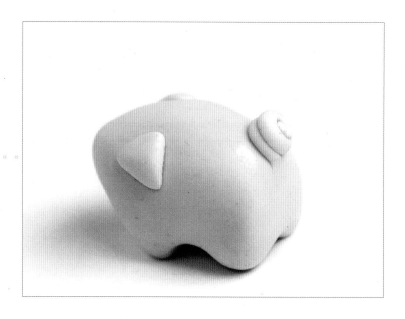

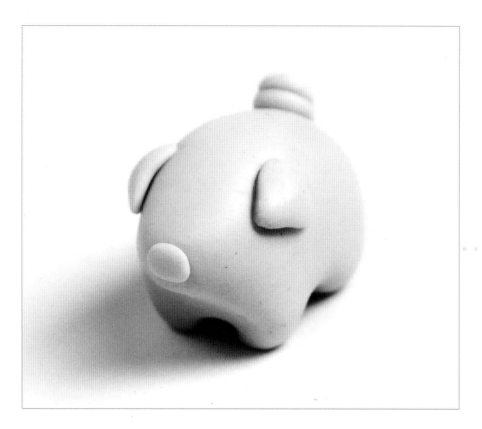

STEP 11

Make a tiny oval disc for the pig's nose. Attach it to the head, using your nail to press it down securely.

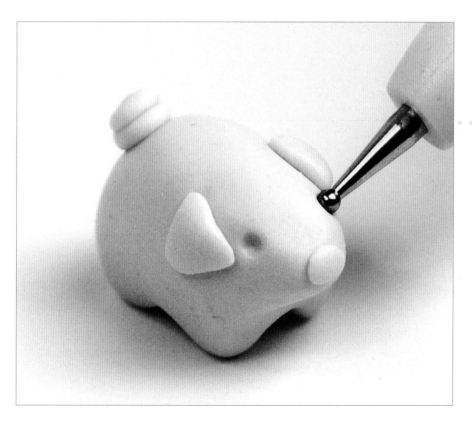

STEP 12

Use a smaller round tool to make indents where the eyes will go.

STEP 13

Make indents on the snout as well.

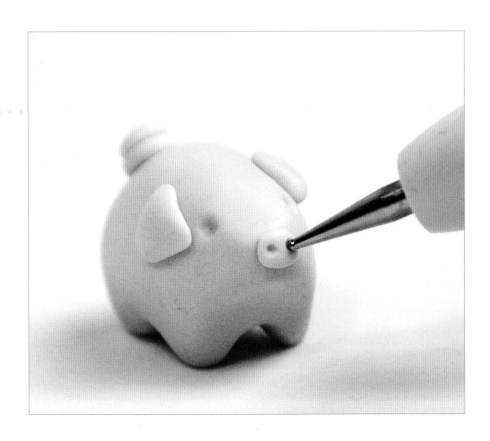

STEP 14

Form tiny black balls the size of the eye indents, and place them on the pig.

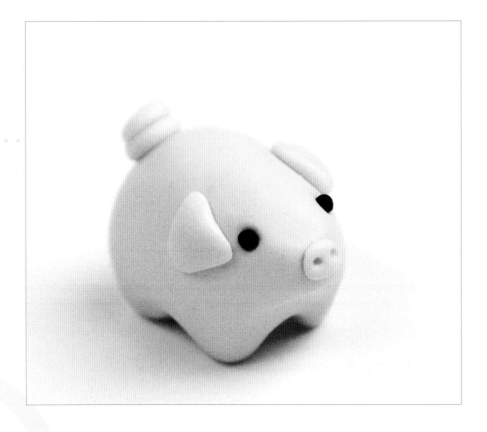

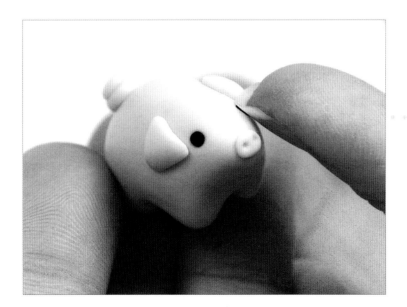

STEP 15
Use your nail to flatten the balls to fit into each hole.

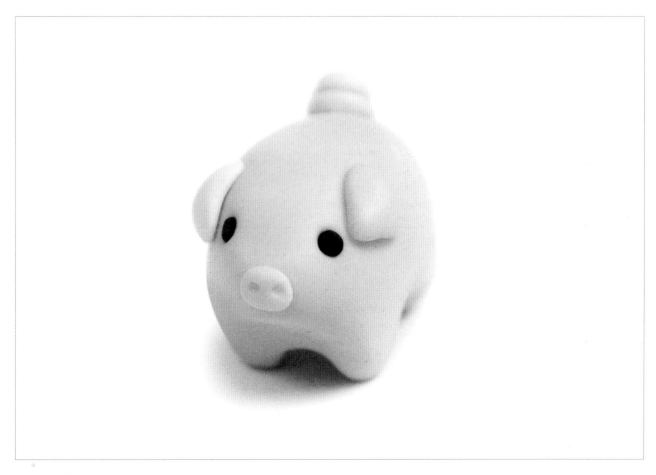

STEP 16
Finish up your pig by baking it according to the instructions on the package of clay.

COW

Moo! This adorable little cow is sure to delight
any animal lover!

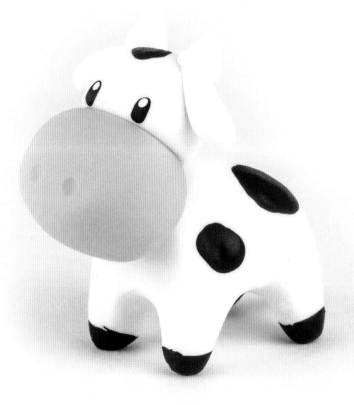

TOOLS & MATERIALS

- Polymer clay in pink and white
- Round detail tool
- ½" (12 mm) piece of wire
- Acrylic paint in white and black

STEP 1

Roll the pink clay into an oval shape. Then, with a ball of white clay about one-third the size of the pink oval, form a half-circle.

STEP 2

Place the white shape on top of the pink oval.

STEP 3

Use white clay to form two long teardrop shapes for the cow's ears.

STEP 4

Attach the ears to either side of the cow's head, and smooth down with your finger.

STEP 5

Make two cones for the horns, each one half the size of the ears, and place them where the ears meet the head.

STEP 6

Use a small, round detail tool to make two dots for the nostrils.

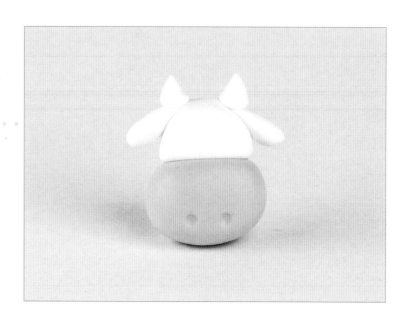

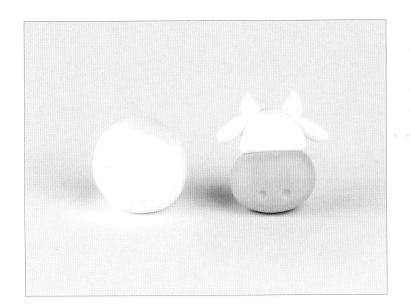

STEP 7

To create the cow's body, form a ball of white clay that's about the same size as the finished head.

STEP 8

Make a thick, rectangular shape and use your finger to press the middle into the shape of a packing peanut.

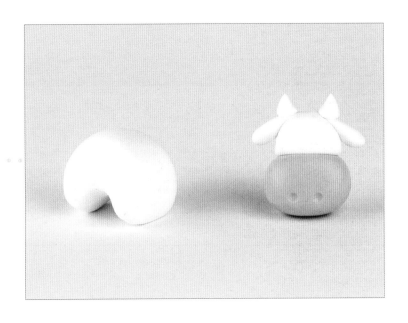

STEP 9

Pinch each corner slightly to pull out the legs. Repeat until you've created four legs. Place the cow upright to check if it stands evenly, and adjust the legs as needed.

STEP 10

Push the piece of wire into the cow's body.

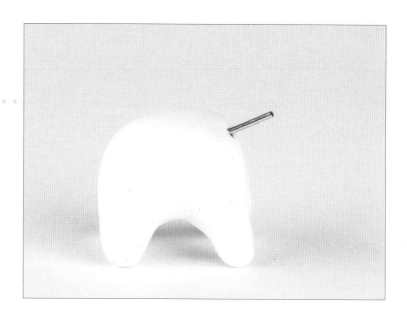

STEP 11

Place the cow's head onto the wire, inserting it into the pink section of the head.

STEP 12

With white clay, form a tapered snake for the cow's tail. Attach it to the cow's backside and smooth it down.

STEP 13

Create a small seed shape and place it on the tip of the cow's tail. Bake your piece according to the instructions on the package of clay. Let it cool.

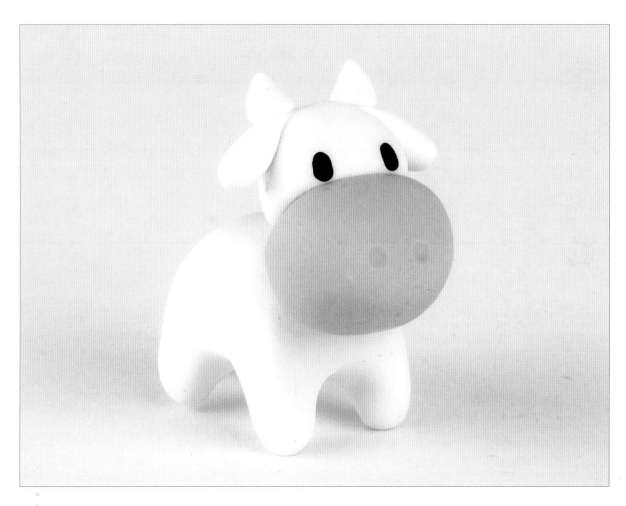

STEP 14

With black paint, add two dots for the cow's eyes.

STEP 15
Randomly paint black spots across the cow's body.

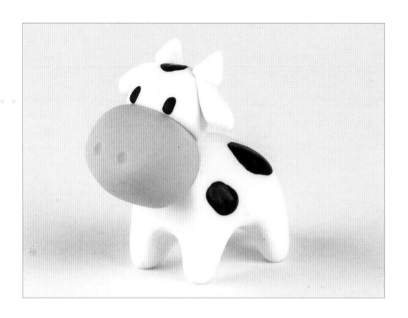

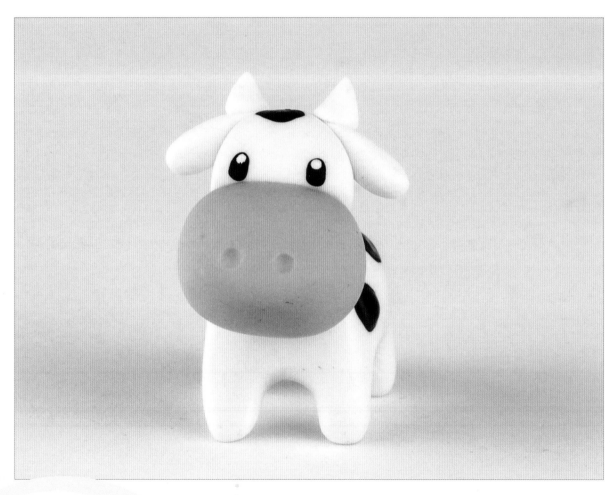

STEP 16
With white paint, make two small dots on the cow's eyes.

STEP 17

Paint the hooves black and allow to dry.

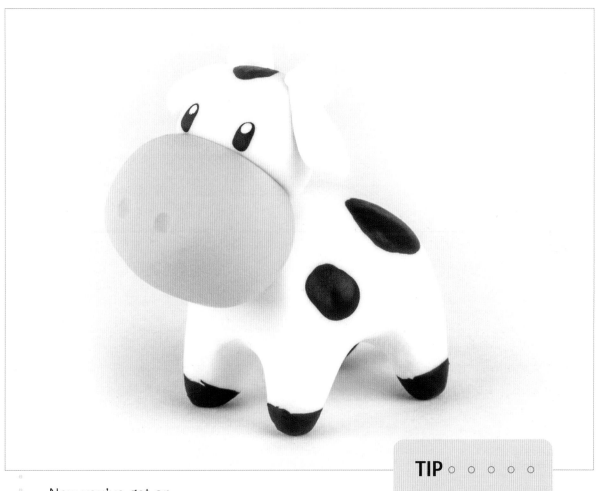

Now you've got an adorable cow!

TIP ○ ○ ○ ○ ○

Try mixing it up and creating a brown or gray cow!

UNICORN

This unicorn is a little more complicated to make than the previous animal creations. But once you've mastered the basic shapes, let your imagination run wild and use different colors and designs to create your own original unicorns!

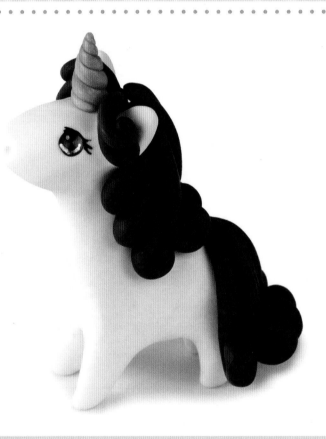

TOOLS & MATERIALS

- Polymer clay in white, purple, and gold
- Round detail tool
- Toothpick or small round detail tool
- ½" (12 mm) piece of wire (any gauge)
- Blade tool
- Acrylic paint in purple, black, and white

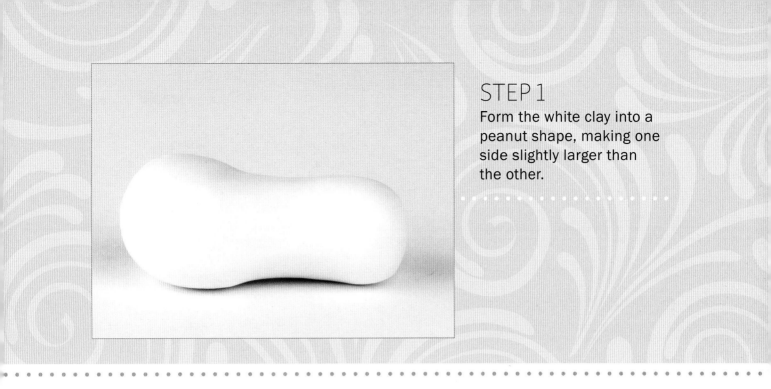

STEP 1

Form the white clay into a peanut shape, making one side slightly larger than the other.

STEP 2

Pull and fold up the two ends to form a 90-degree angle.

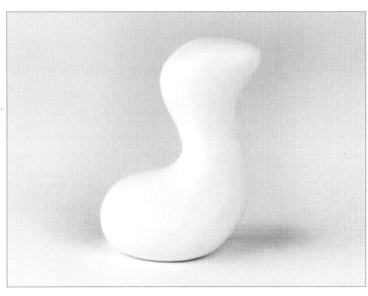

STEP 3

Pinch the bottom of the shape to form the unicorn's legs.

STEP 4

Continue to pinch the legs until they're all the same length and the unicorn stands evenly.

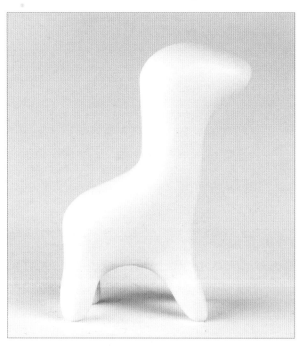

STEP 5

Form two small balls of white clay.

STEP 6

Shape the two balls into thick leaves and place them on the sides of the unicorn's head.

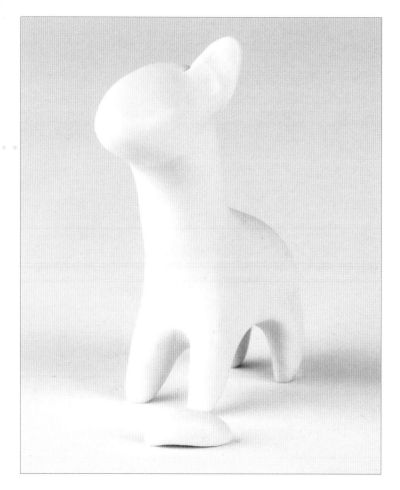

STEP 7
Use your finger to smooth down the ears where they meet the head.

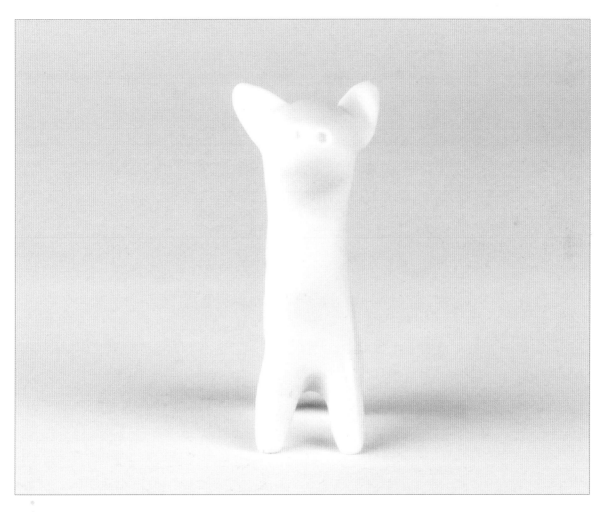

STEP 8
Using a toothpick or small round detail tool, make two holes for the nostrils.

STEP 9

Push the piece of wire into the unicorn's head where the horn will go.

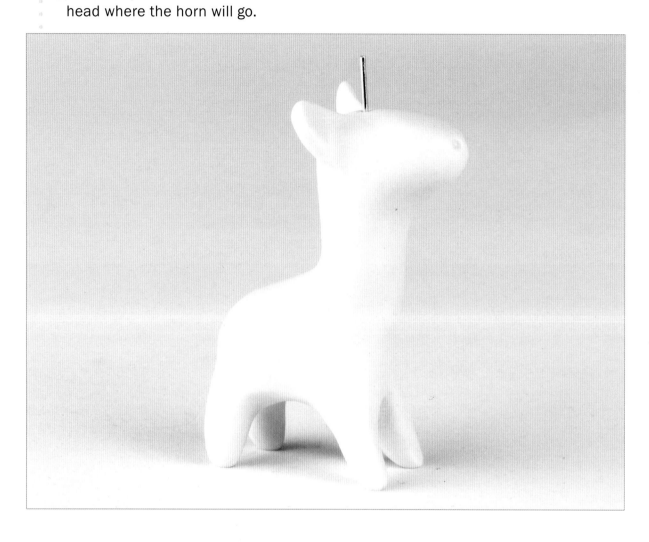

STEP 10

With the gold clay, form two tapered snake shapes that are slightly shorter than the unicorn's head.

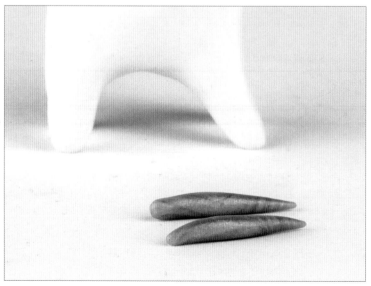

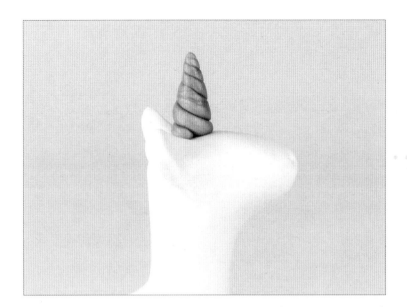

STEP 11
Twist the two gold shapes together to form the unicorn's horn and place this on the wire, with the thinner end forming the top of the horn.

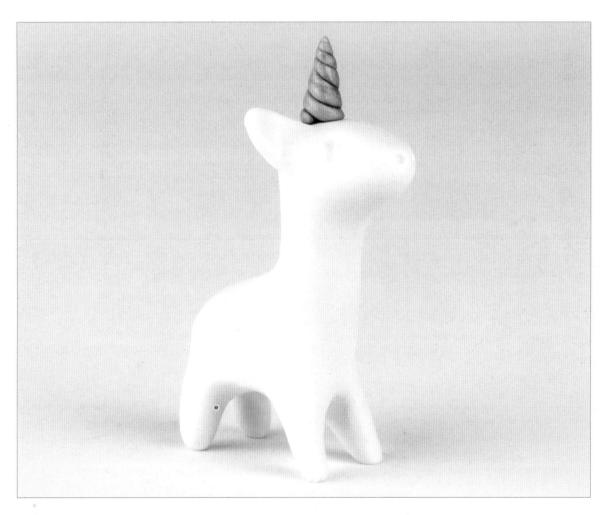

STEP 12
Use a round detail tool to make holes for the unicorn's eyes.

STEP 13

Now it's time to make the unicorn's mane! Start by forming a small snake of purple clay.

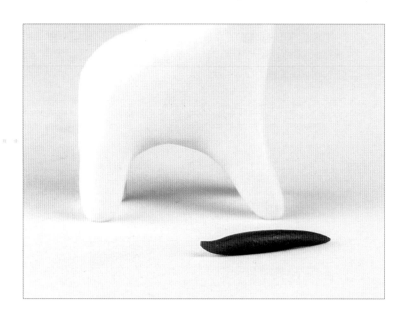

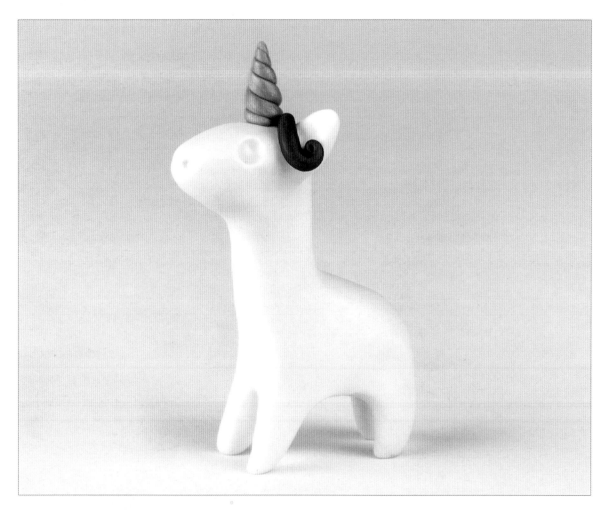

STEP 14

Curl up one end of the purple snake and place it on the unicorn's head between its horn and ear.

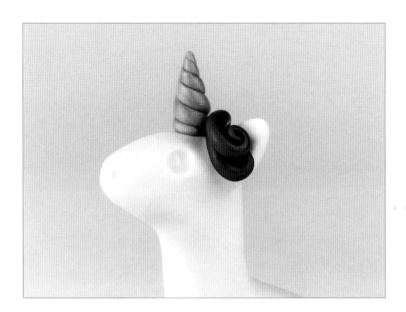

STEP 15
Form another purple strand of hair and place it on top of the first one.

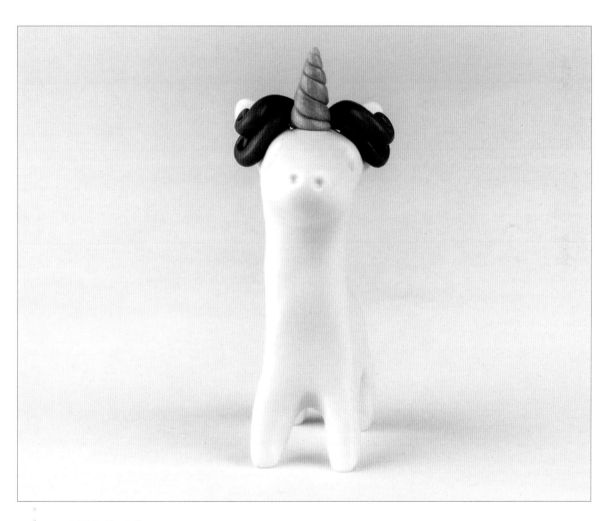

STEP 16
Repeat steps 13–15 on the other side of the unicorn's head.

STEP 17

Now form 6 strands of hair, making each one progressively longer. Add these to the sides of the unicorn's neck.

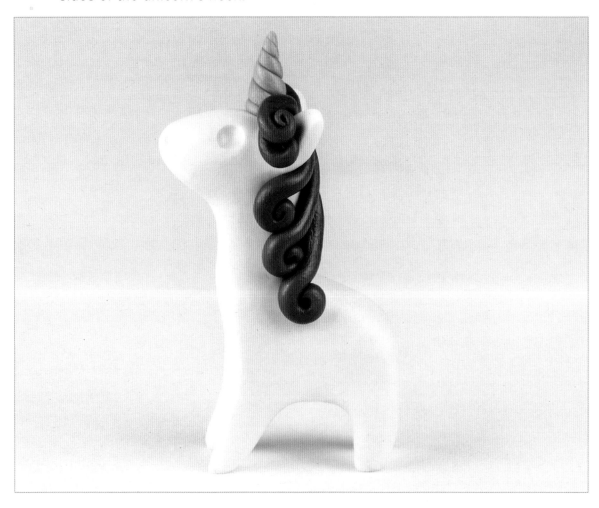

STEP 18

Make 3 more strands of hair to cover the back of the unicorn's neck.

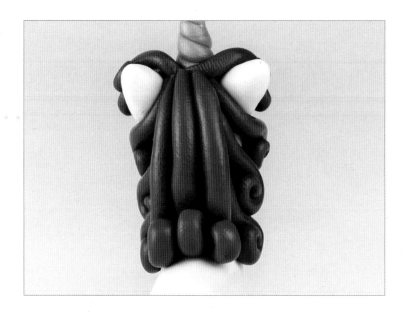

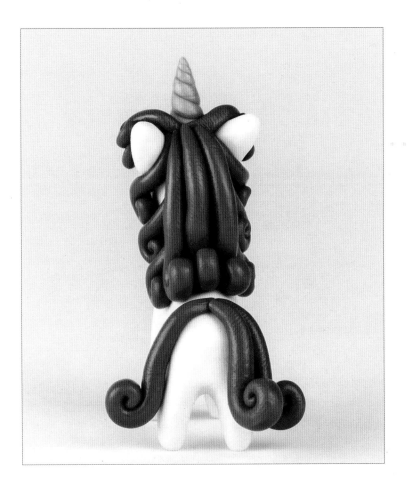

STEP 19

For the tail, make 6 strands of hair and add these to the unicorn's backside, moving from the outside in.

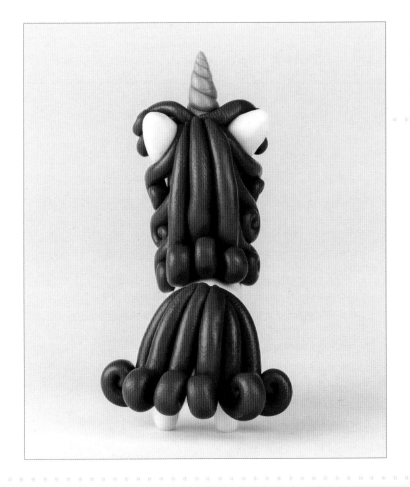

STEP 20

Then bake the unicorn according to the instructions on the package of clay.

STEP 21

Let the unicorn cool after baking. Then use purple paint to fill in its eyes.

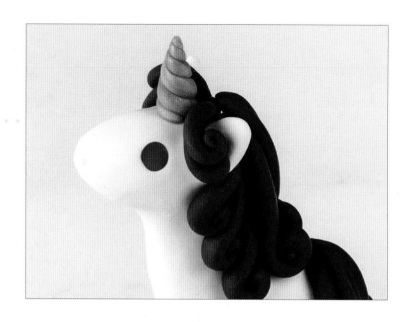

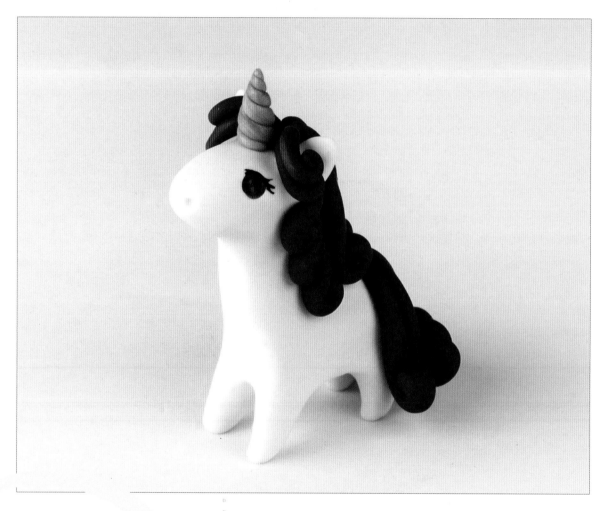

STEP 22

Use black paint to add details to the eyes, such as eyelashes.

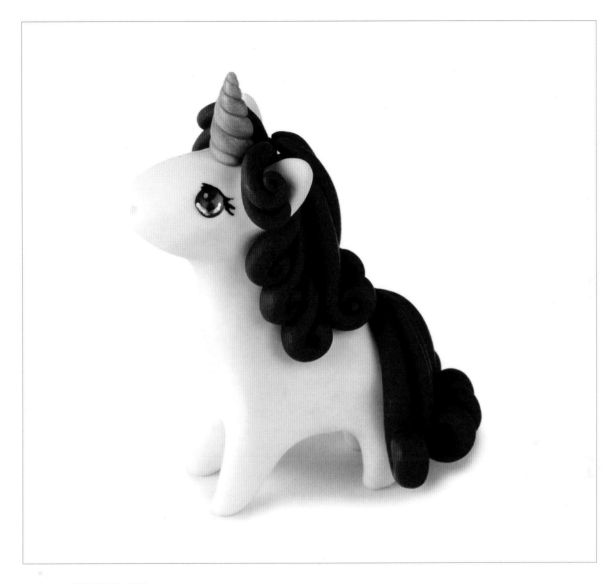

STEP 23

Allow to dry. Then use white paint to add a small dot on the outer corner of each eye and a U-shape along the bottom. This will bring your unicorn to life!

PLANTS

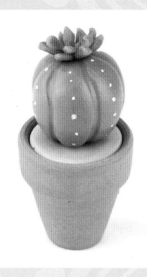

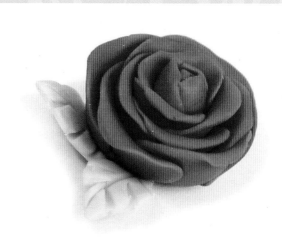

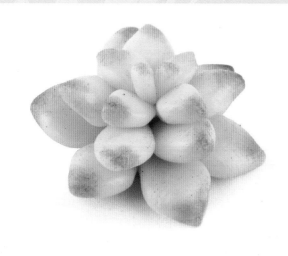

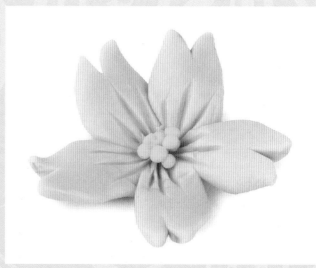

SUCCULENT

Succulents are hardy, drought-resistant plants that come in many beautiful shapes and colors. Once you've learned how to make one using polymer clay, you can try using different colors of clay to create a variety of succulent plants.

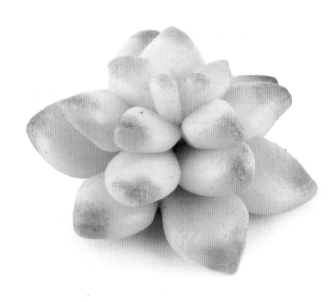

TOOLS & MATERIALS

- Polymer clay in light green and translucent, mixed in a 1:1 ratio
- Round detail tool
- Red chalk pastel
- Blade tool
- Fine-tipped paintbrush

STEP 1

Separate your clay mixture into balls of 4 different sizes. You will need 6 large balls, 5 slightly smaller ones, 4 even smaller, and 2 very small.

STEP 2

Create a leaf shape with the largest ball by pinching both ends with your fingers.

STEP 3

Repeat with the other 5 balls of clay, and arrange them together in a flat circle.

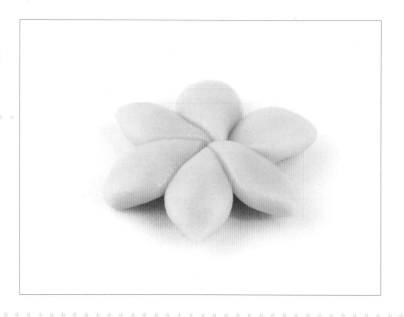

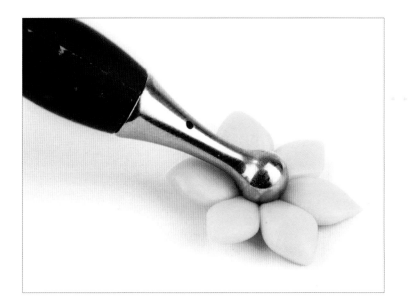

STEP 4

Use the round detail tool to create a dip in the center.

STEP 5

With the next 5 slightly smaller balls, create leaves and arrange them as shown.

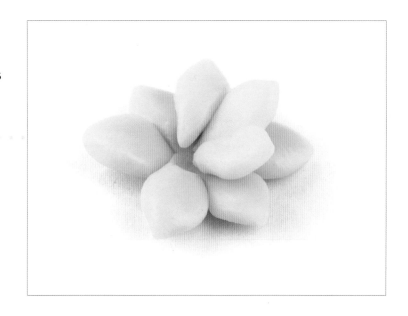

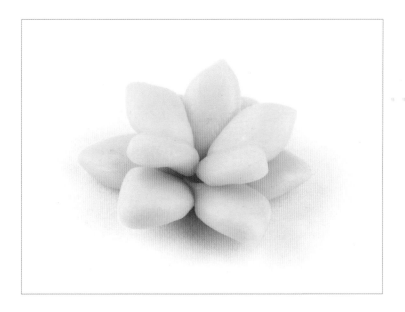

STEP 6

Position these leaves between the leaves in the first row.

STEP 7

Repeat with the next
4 smaller-sized balls.

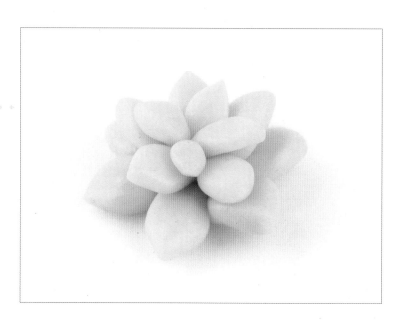

STEP 8

Form 2 leaves from the
smallest-sized balls of clay.
Pinch only one side of each
leaf to create the shape
shown here.

STEP 9

Place the smallest leaves
in the center of the
succulent.

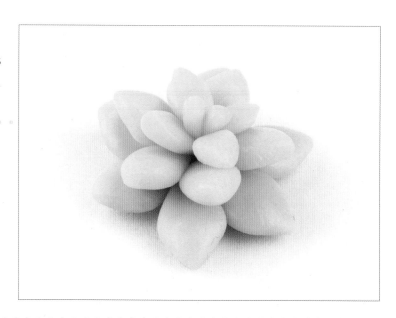

STEP 10

Prepare your red chalk pastel by shaving tiny flakes from it using a blade tool.

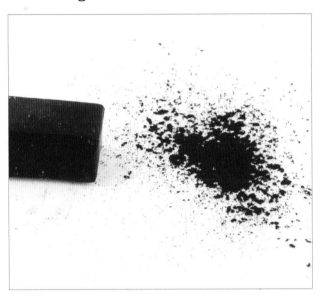

STEP 11

Use a small paintbrush to apply the red chalk pastel to the tip of each leaf, starting with the largest leaves and moving inward.

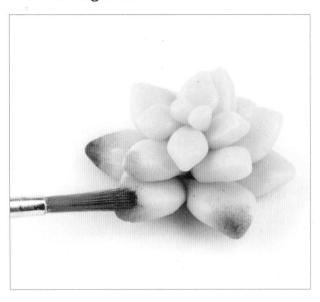

STEP 12

Bake your piece in the oven according to the directions on the package of clay. Finish with a glaze if desired. (See pages 20–21 for glazing instructions.)

CACTUS

Cacti are fun and easy to create! Once you've learned how to form the simple, round cactus shown here, you can start experimenting with all different shapes, colors, and sizes of cacti.

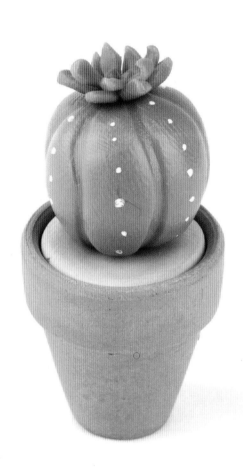

TIP ○ ○ ○ ○

Small clay pots can be found in the floral section of art and craft stores.

TOOLS & MATERIALS

○ Polymer clay in olive green, pink, and beige
○ Pointed detail tool or sewing pin
○ White paint
○ Miniature clay pot

STEP 1

Start by forming a ball of olive-green clay. Using the side of a pointed detail tool or a sewing pin, make 6 evenly spaced vertical lines in the ball.

STEP 2

Paint 7 white dots down each section of the cactus.

Start by making a large dot in the center. Continue on either side, making the dots smaller as you reach the ends of each section.

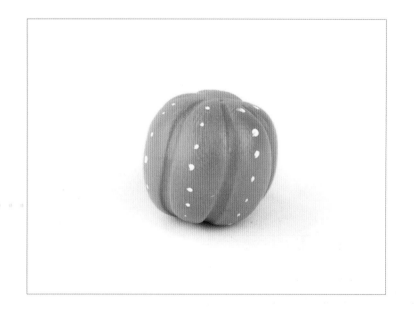

STEP 3

While the paint dries, prepare a small ball of pink clay.

STEP 4

Separate the pink clay into 11 tiny balls. Create a flower petal by flattening and pinching both ends of the pink clay. Repeat until you've formed 11 petals.

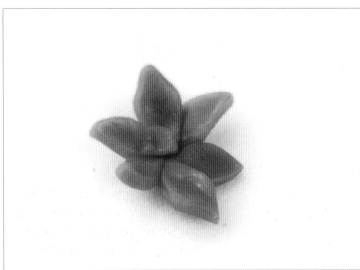

STEP 5

Arrange 6 petals together in a circle.

STEP 6

Create a second row of petals by arranging the remaining 5 petals between the first 6.

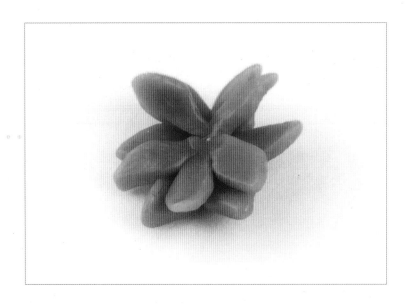

STEP 7

Gently place the flower on top of the cactus.

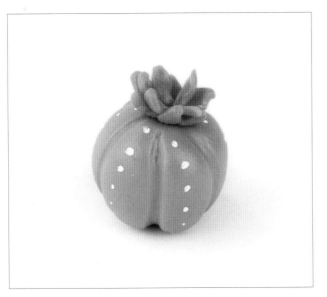

STEP 8

Fill the miniature pot with beige clay.

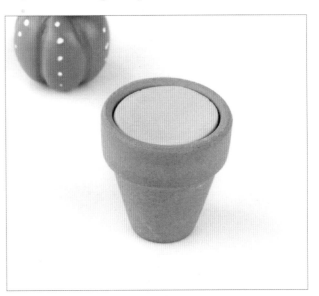

STEP 9

Place the cactus on top of the pot. Bake your piece in the oven according to the directions on the package of polymer clay.

Note: Polymer clay is baked at such a low temperature that the heat won't affect the paint or the clay pot.

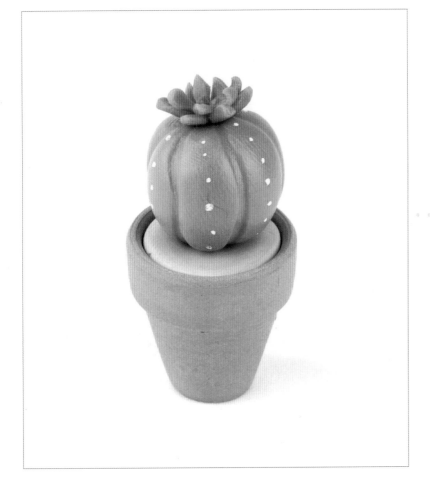

ROSE

Roses are beautiful, intricate flowers. Although they may look complicated, once you've got the technique figured out, they are quite simple to make!

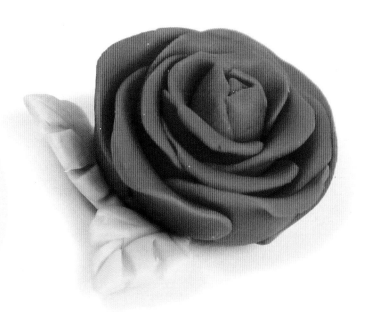

TOOLS & MATERIALS

○ Polymer clay in fuchsia and green
○ Pointed detail tool or sewing pin
○ Flat detail tool

STEP 1

Make a small ball of fuchsia clay, and taper the two ends to create a seed shape.

STEP 2

Using fuchsia clay, create a small, flat oval, and place the seed in the center of it.

STEP 3

Wrap the sides up around the center.

STEP 4

Make another flat oval, and place the shape you created in step 3 facedown in the middle of the oval.

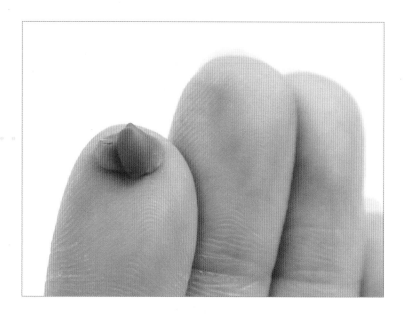

STEP 5

Wrap the sides up to create a flower bud with a bit of the original seed peeking out.

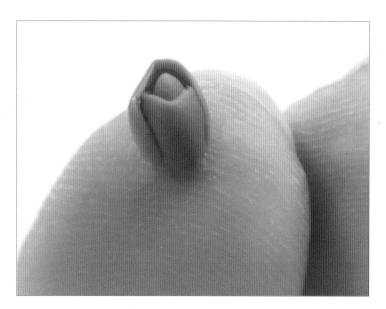

STEP 6

Make a slightly bigger, flat oval, and place the bud in the center.

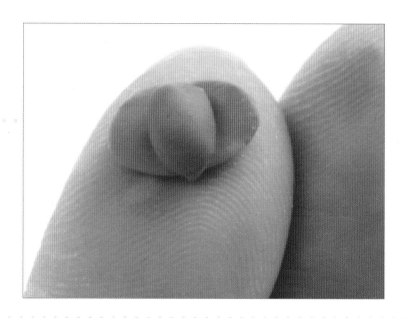

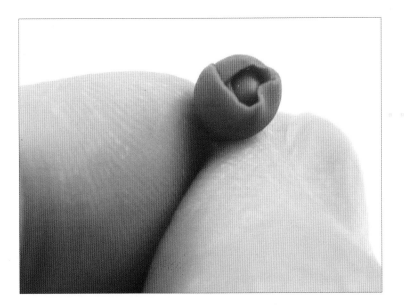

STEP 7

Wrap the oval around the bud, and pinch the two sides slightly.

STEP 8

Make another, larger petal, and wrap it around the bud you created in step 7. Use your finger to lightly pull the petal down and away from the bud.

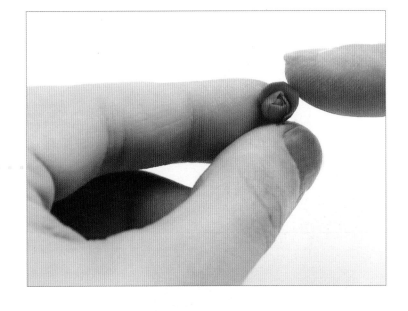

STEP 9

Repeat the entire process, creating another petal roughly the same size and overlapping the first one. Again, pull the petal down and away from the bud.

STEP 10

Continue forming more petals, overlapping them as you go and making the petals slightly larger with each layer.

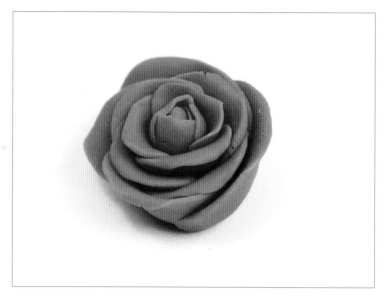

STEP 11

Grab two small pieces of green clay. They should each be about the same size as the center of the flower.

STEP 12

Flatten and pinch the pieces to create two leaf shapes. Then use a pointed tool or a pin to press a line down the center of each leaf.

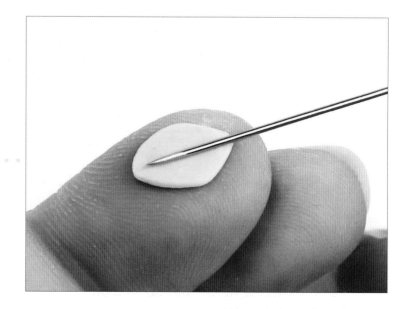

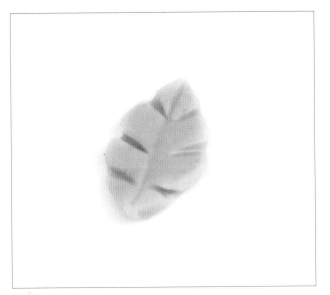

STEP 13

Make three angled lines down each side of both leaves.

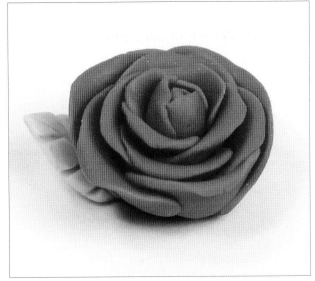

STEP 14

Attach the first leaf to the rose with the lined side up. Repeat with the other leaf.

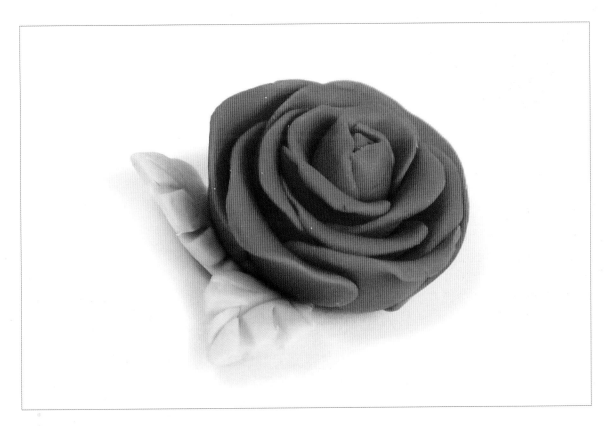

STEP 15

To finish up your rose, bake it in the oven according to the instructions on the package of clay.

CHERRY BLOSSOM

Cherry blossoms are lovely flowers that signal the start of spring in many areas, from Japan to Washington, D.C.

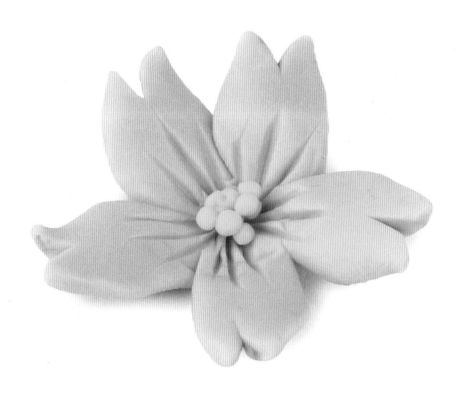

TOOLS & MATERIALS

○ Polymer clay in pink and yellow
○ Blade tool
○ Pointed detail tool or sewing pin

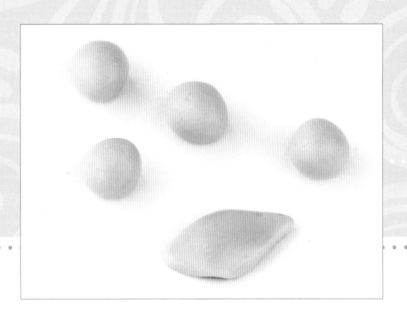

STEP 1

Divide the pink clay into 5 even, round portions. Form flower petals by flattening and then pinching both ends of the clay balls.

STEP 2

Using a blade tool, make a small slice in the center of one end of each of the petals.

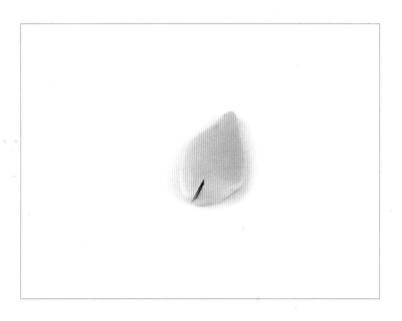

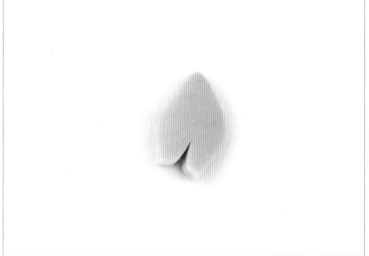

STEP 3

Gently pull the two parts of the petal outward, and repeat with the remaining pink clay.

STEP 4

Arrange the petals next to each other in a circle, cut side out. Press down in the center of the petals so that they stick together and to create a slight indent in the middle of your cherry blossom.

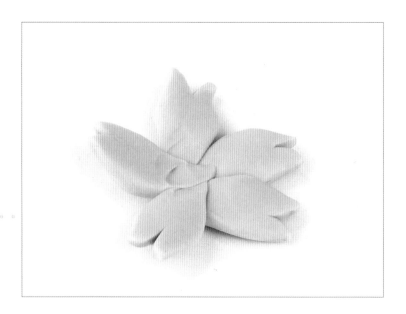

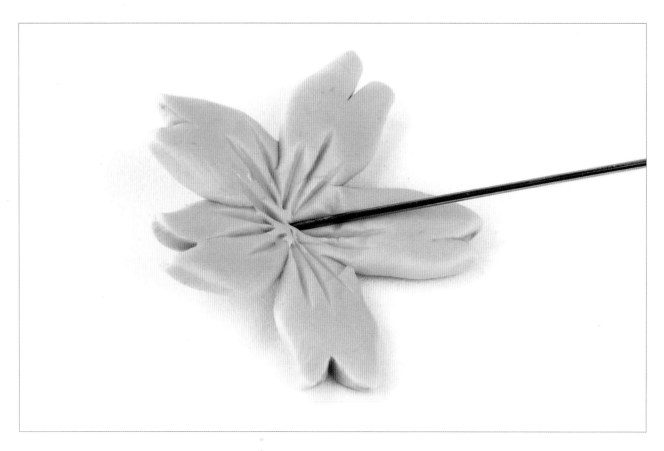

STEP 5

Using a pointed detail tool or sewing pin, score each petal with three lines. The center line of each petal should be longer than the other two.

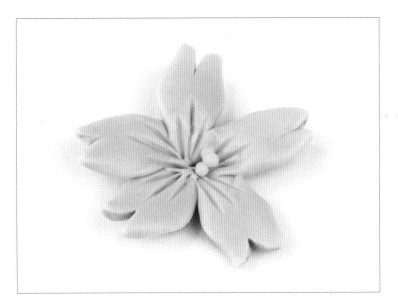

STEP 6
Roll out 8 to 12 small balls of yellow clay, and fill in the center of the flower.

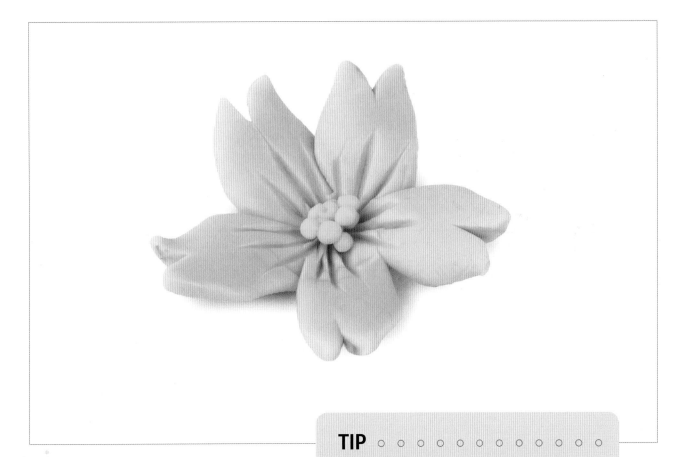

STEP 7
Bake your piece in the oven according to the directions on the package of clay.

TIP ○ ○ ○ ○ ○ ○ ○ ○ ○ ○ ○ ○

Now that you've learned to make a cherry blossom, let your imagination run wild! Use these flowers to accent other pieces, like dainty little unicorns and larger floral arrangements. You can also use a variety of colors to form your blossoms.

BEADS

Bead-making is another popular use for polymer clay and a great way to use up your scrap clay! Let's try making two shapes of beads: round and geometric.

ROUND BEAD

TOOLS & MATERIALS

○ Polymer clay in white and blue
○ Toothpick

STEP 1

Start with a small ball of blue clay and a small ball of white clay. Pull and pinch both colors to form two long rectangles. Then place the colors together.

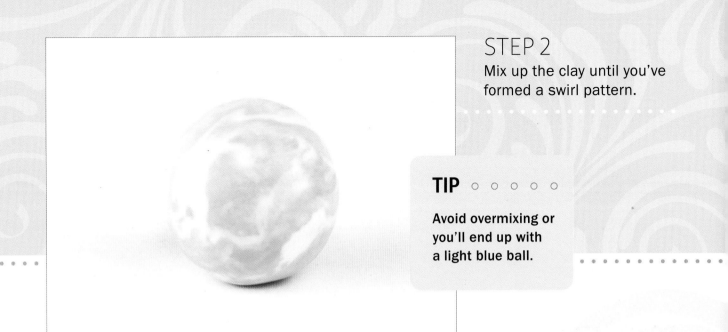

STEP 2

Mix up the clay until you've formed a swirl pattern.

TIP ○ ○ ○ ○ ○

Avoid overmixing or you'll end up with a light blue ball.

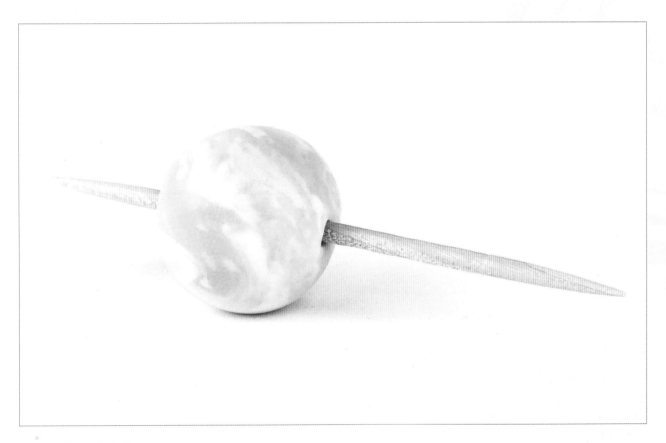

STEP 3

With a toothpick, poke a hole through the center of the bead. Then bake it according to the directions on your package of clay.

GEOMETRIC BEADS

TOOLS & MATERIALS

○ Pink polymer clay
○ Blade tool
○ Toothpick

STEP 1

Start with a small ball of clay. Using a blade tool, make random cuts around the side of the ball.

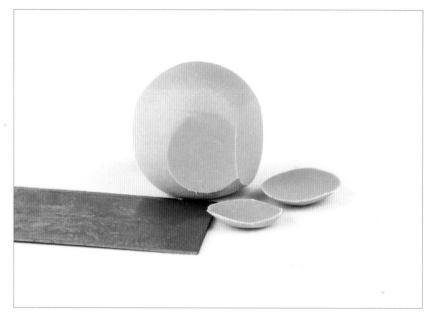

STEP 2

With a toothpick, make a hole through the center of the bead. Bake according to the directions on the package of clay.

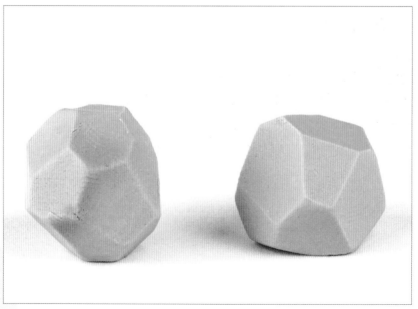

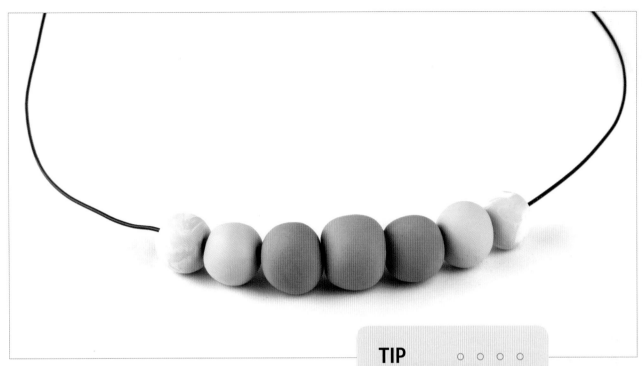

Add your polymer clay beads to a necklace chain or string for a fun, stylish look!

TIP ○ ○ ○ ○

After baking your beads, you can also use a small drill to make holes.

TIP ○ ○ ○ ○ ○ ○

Once you've baked and cooled your beads, use sandpaper to buff out any imperfections.

ABOUT THE ARTIST

EMILY CHEN is a self-taught polymer clay artist, owner of Cat Bear Express, and author of *Kawaii Polymer Clay Creations*. Her work is inspired by everyday life, from food in the kitchen to the flowers in the garden. She is an advocate of lifelong learning and can often be found reading about and experimenting with new techniques. Emily also loves hearing from her readers, whether it's answering questions about clay or sharing photos of inspired projects! Find her on Etsy, Instagram, and Facebook at Cat Bear Express.